AFRICAN-AMERICAN MADE

AFRICAN-AMERICAN MADE

A PHOTO JOURNAL OF SIX FAMILIES: JONES-HARDIN, DAVIS-MEACHAM, WATSON-ROBINSON

MARION HILL

Copyright © 2019 by Marion Hill.

Library of Congress Control Number:		2019909964
ISBN:	Hardcover	978-1-7960-4657-1
	Softcover	978-1-7960-4656-4
	eBook	978-1-7960-4655-7

All rights reserved. No part of this book may be reproduced or transmitted in any form or by any means, electronic or mechanical, including photocopying, recording, or by any information storage and retrieval system, without permission in writing from the copyright owner.

Any people depicted in stock imagery provided by Getty Images are models, and such images are being used for illustrative purposes only.
Certain stock imagery © Getty Images.

Print information available on the last page.

Rev. date: 07/17/2019

To order additional copies of this book, contact:
Xlibris
1-888-795-4274
www.Xlibris.com
Orders@Xlibris.com
777734

AFRICAN-AMERICAN MADE

A PHOTO JOURNAL OF SIX FAMILIES:

JONES-HARDIN, DAVIS-MEACHAM, WATSON-ROBINSON

INTRODUCTION

To James Madison Davis, my great great Great-grandfather, born in Alabama in 1835, I dedicate this family photo project. James M. Davis is a person I never knew, but of whom I've heard much, and through Documentation have pieced together some details of his life. What is most remarkable is the fact that though born enslaved, he apparently always had dreams for freedom, for the acquisition of land, to be the support of his family, and to educate his children.

He stole himself away from his slave owner at sometime between 1862 and 1863, and from oral accounts given by his children and his statement to the1910 census takers; he joined the (UA) Union Army.

Bible records written by his son Wyatt Daniel Davis indicate that he remarried in 1866 to Sarah Jane Booker in Hernando, Mississippi. A few years later, he moved his family to Arkansas.

Deed Book E in the records of the Arkansas History Commission and tax records of Faulkner County Arkansas show that James owned land and paid taxes on that land in

The census of 1880 enumerate James, his wife Sarah Jane, and three children living and working on their own farm in Faulkner County, Arkansas.

Thank you great, great grandfather James Madison Davis for your fortitude, your faith, and your persistence in pursuing your dream.

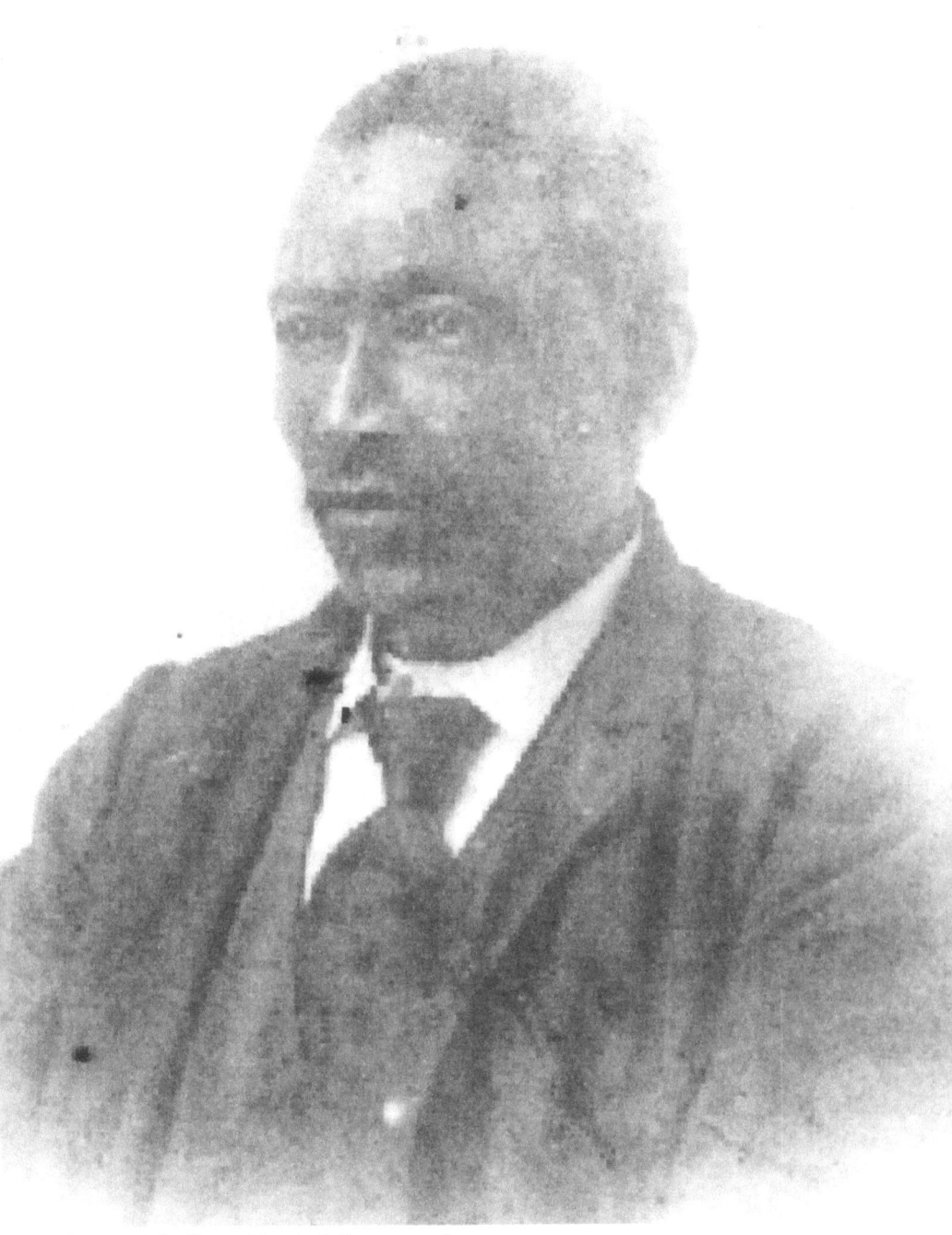

James Madison Davis (1835-1915)
Born in Alabama

Wife Mary (Children: Wyatt, Mattie, Clara, Thomas--born in Mississippi) 2nd Wife Jane (Children: Lucy & Madison)

FOREWORD

I am the family historian and have been collecting photographs for many years. My mother Helen Robinson Hill and I have been researching and recording data from The National Archives, family Bibles, state and county records, and other genealogy sources. We have attended many conferences, lectures, and workshops in order to enhance our research skills.

My goal is to leave an organized record of FAMILY lineage
and history for the generations that follow.
This book is the first of many which I hope to compile.

DEDICATION

This book is dedicated to my mother Helen Hill and all relatives and friends who have contributed, encouraged, and helped me in this project.

ACKNOWLEDGEMENTS

Thank you Mama Robie (Mary Davis Robinson) for carefully keeping the photographs, paintings, and pencil sketches in your suitcase.

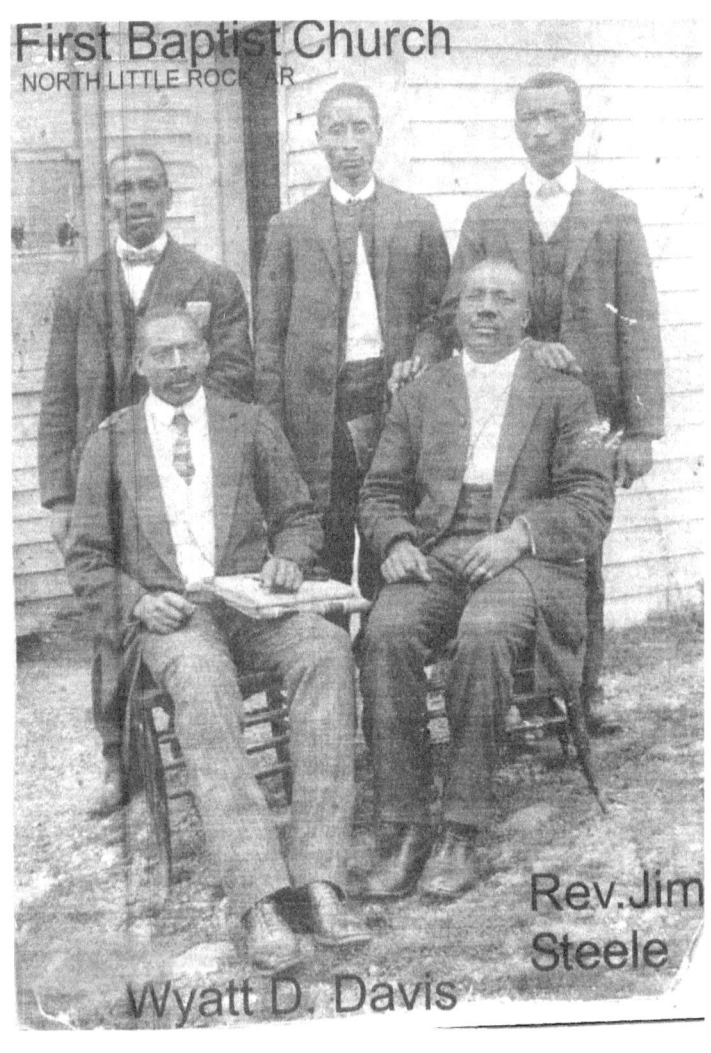

Deacon Wyatt Daniel Davis (Seated with Church Book)

Rev. Jim Steele of First Baptist Church of North Little Rock, AR

Deacons (Standing)

First Baptist Church of North Little Rock, AR

First Baptist Church (N. Little Rock, AR)

Wyatt D. Davis
Church Clerk

WYATT DANIEL DAVIS (With Church Book)

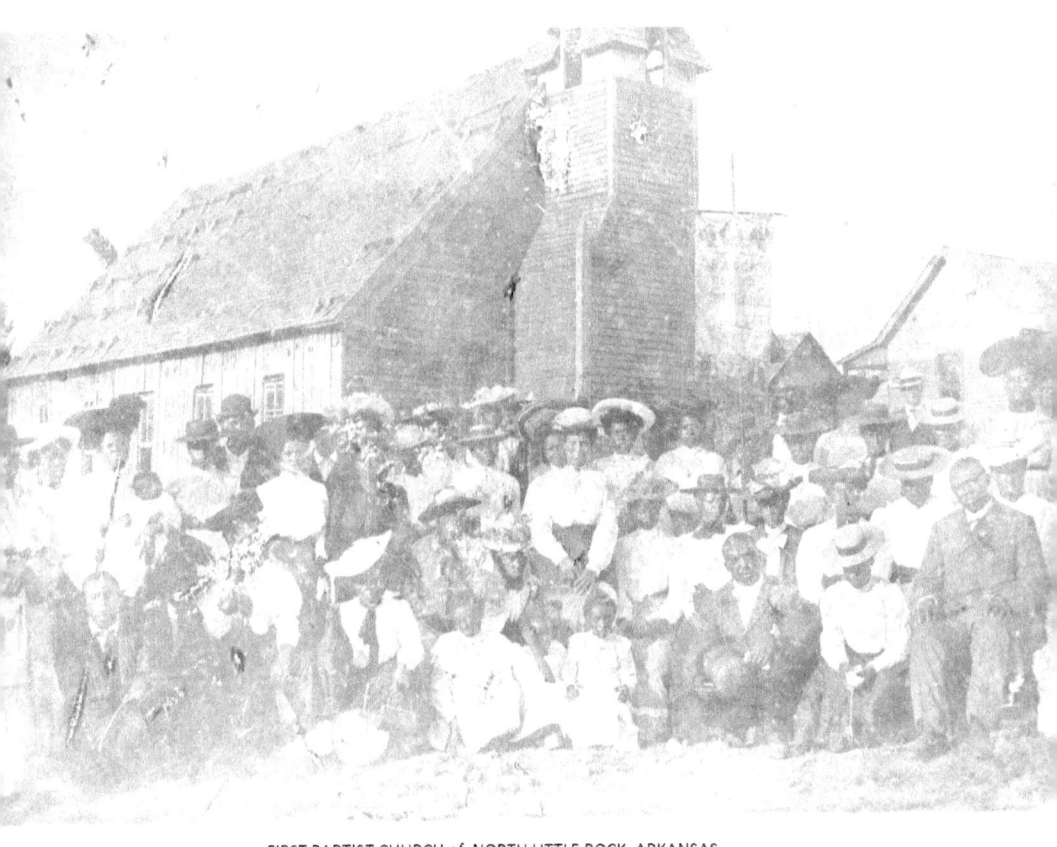
FIRST BAPTIST CHURCH of NORTH LITTLE ROCK, ARKANSAS

AT THE TIME OF THIS CHURCH PHOTO, WYATT DANIEL DAVIS WAS THE HEAD DEACON AND THE CHURCH CLERK OF THE FIRST BAPTIST CHURCH IN NORTH LITTLE ROCK (ARGENTA), ARKANSAS

ON THE 2ND DAY OF OCTOBER, 1914, WYATT RECEIVED THIS LICENSE TO PREACH

Rev. Wyatt Daniel Davis was born in 1859 to James Madison Davis and Mary Davis somewhere on a plantation in Marshall County, Mississippi. When his father ran away to attach himself to a part of the Union Army in Tennessee, Wyatt's mother, Mary, married a Mr. Stephen Coppage, and my research finds them in DeSoto County, MS in 1870.

Later Wyatt's father James M. Davis returned and took his two sons, with his second wife Sarah Jane, to Arkansas. The 1880 census enumerates James Davis, his second wife Sarah Jane Booker Davis, sons Wyatt and Thomas Davis, and two children Lucy and Madison Davis. Though he had no formal education, his children and grandchildren can vouch for the fact that he had learned to read, to write, and to speak well.

He recorded birth, marriage, and death records in our family Bible.

In 1887, Wyatt D. Davis married Sarah Jones who also lived in Faulkner County, AR.

To this union were born five children: Mary (my grandmother), George, Sandy, Cornelius, and one child who died in infancy.

The 1900 and 1910 census records indicate that Wyatt had moved his family to North Little Rock (Argenta), AR and they resided in their home at 1823 Chandler. Wyatt worked primarily as a carpenter; however, the 1900 census lists his occupation as day laborer for the Iron Mountain Railroad. Wyatt was a carpenter, a railroad yardman, a preacher, and a musician.

He purchased a pump organ for his daughter Mary's 17th birthday. He could play the organ and also taught others to play. That organ was brought to Chicago when Wyatt and Sarah moved to Chicago in 1921.

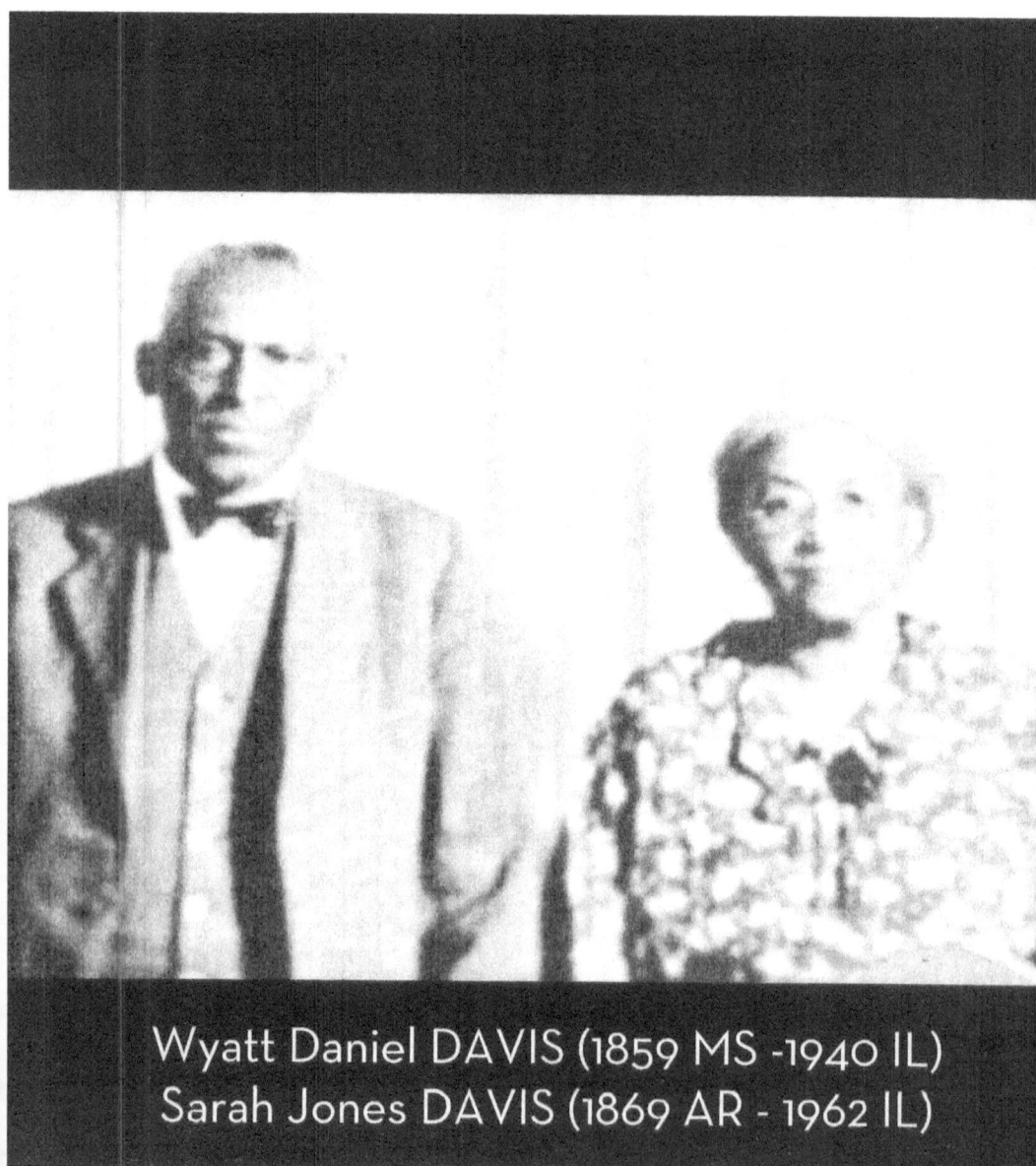

Wyatt Daniel DAVIS (1859 MS -1940 IL)
Sarah Jones DAVIS (1869 AR - 1962 IL)

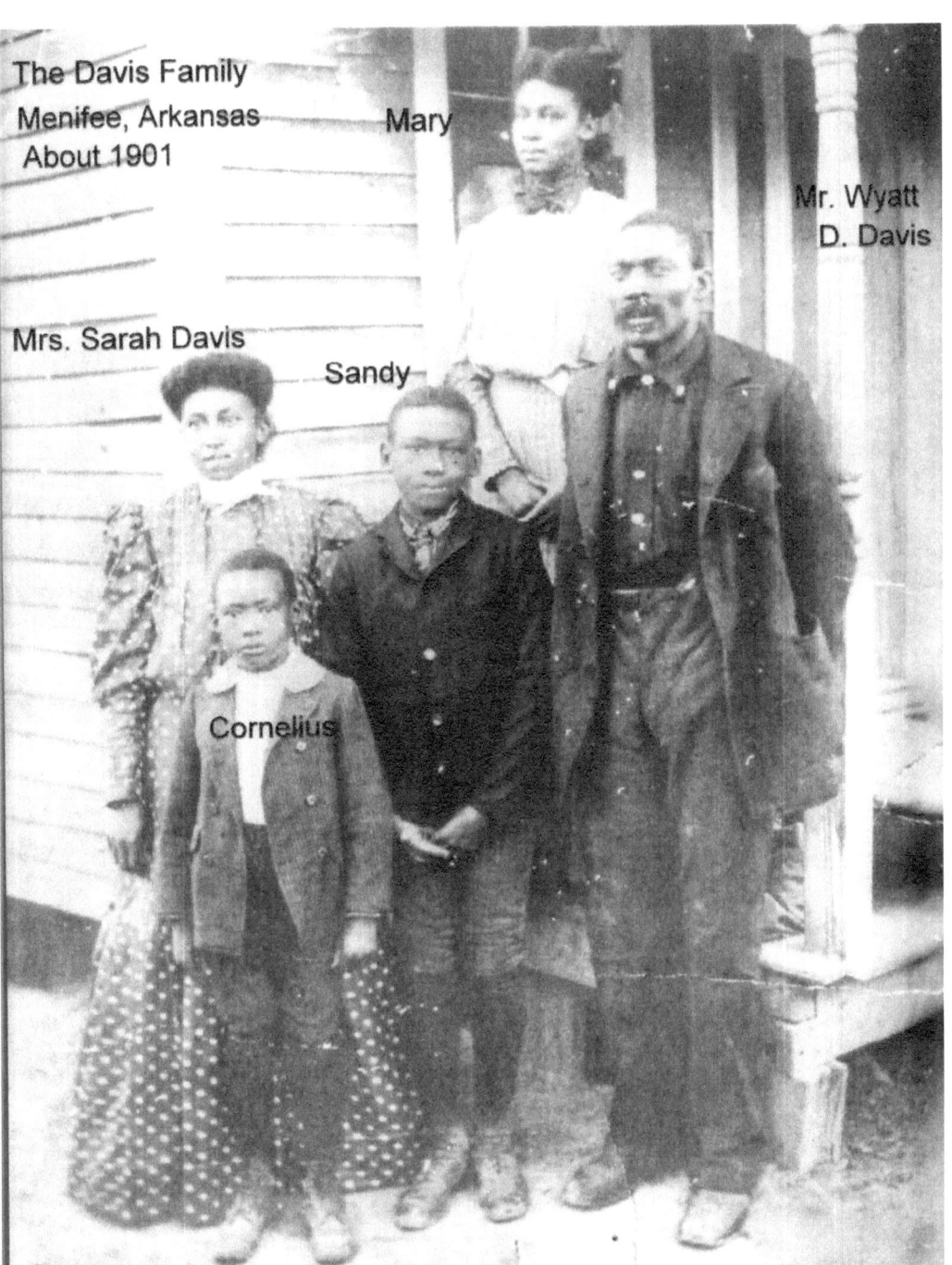

SARAH JONES DAVIS

MARY DAVIS ROBINSON
1887-1985

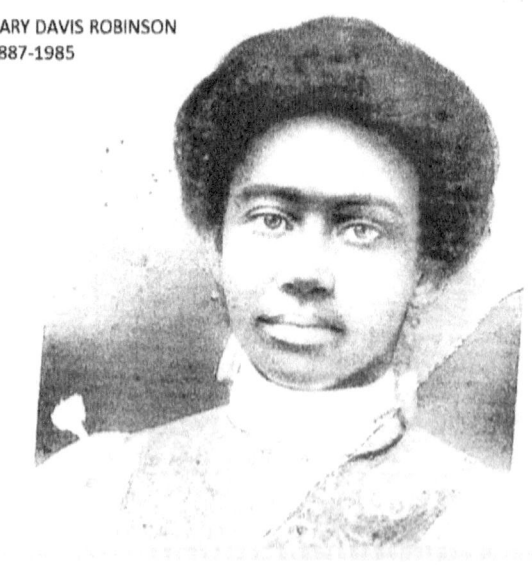

PAINTINGS

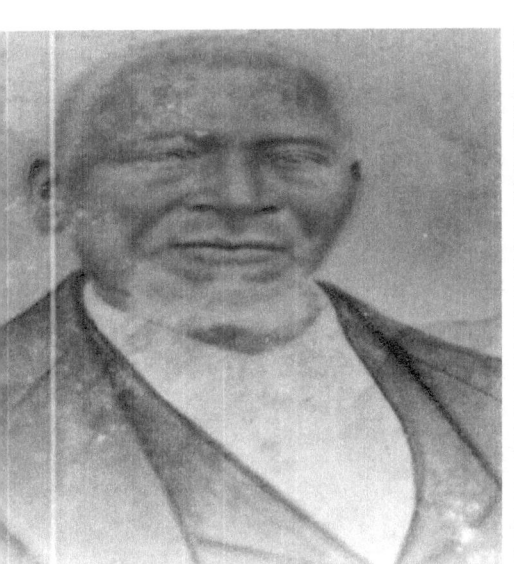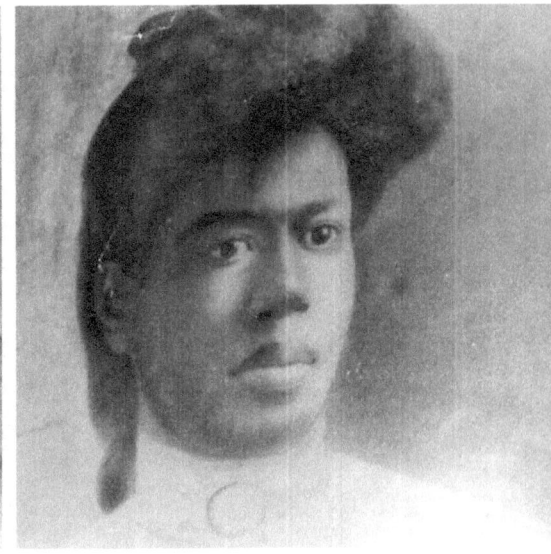

JAMES MADISON JONES (1834 AR- 1871 AR) and Wife
EVALINE HARDIN JONES (1837 AR -1892 AR)

JAMES MADISON JONES
(1834 - 1871)

James Madison Jones was born in 1834 in the Arkansas Territory. James, along with his wife Evaline Hardin Jones were slaves of Dr. J. J. Jones of Conway County, Arkansas.

To the union of James and Eva line were born eight children: Catherine, Elizabeth, James, Albert, Aderson, William, Sarah, and Jane.

Along with his brother-in-law Allen Hardin, James M. Davis filed an application in August of 1870 for an Arkansas homestead. The document shows no X for James' name; he neatly signed his own name.

Unfortunately, James died in 1871 before receiving the homestead.

Albert G. Grotten (also a brother-in-law of James), acted as administrator for the estate of James Madison Jones.

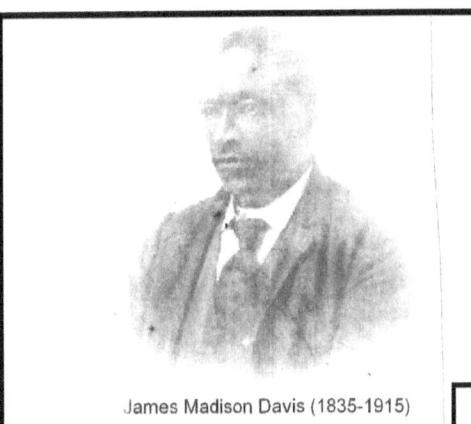

James Madison Davis (1835-1915)

James Madison Davis
first Wife (Mary)
Children: Mattie, Wyatt, Clara, Thomas
2nd Wife (Sarah Jane Booker)
Children: Madison and Lucy

Mary Davis (Coppage)
1840 AL - 1914 AR

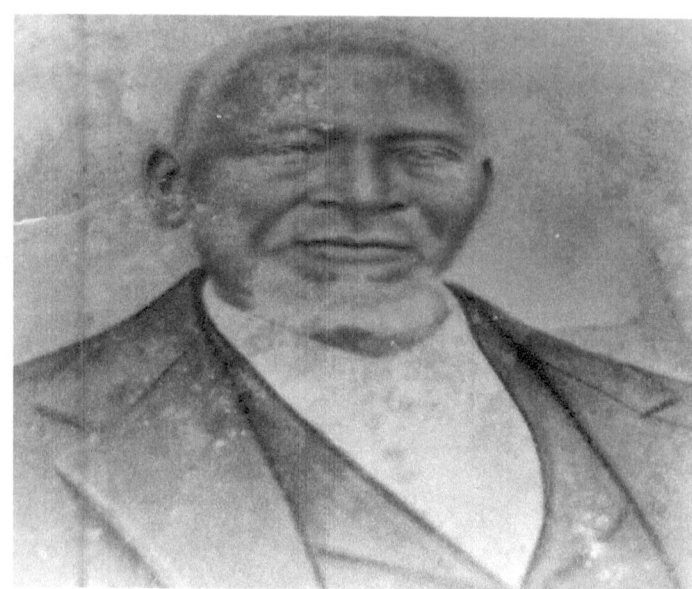

James Madison Jones
1834 AR - 1871 AR
Husband of Eveline Hardin Jones

Eveline Hardin Jones
1837 AR - 1892 AR
Wife of James Madison Jones

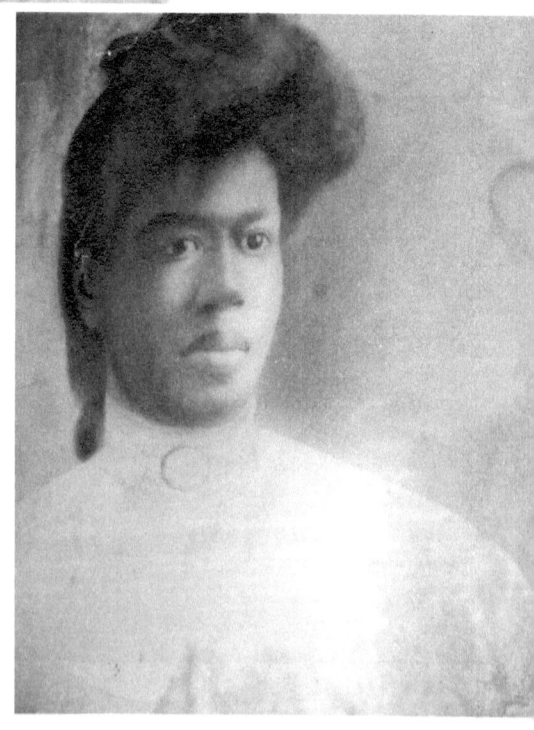

PAINTING

ALLEN HARDIN
1828 AR - 1871 AR

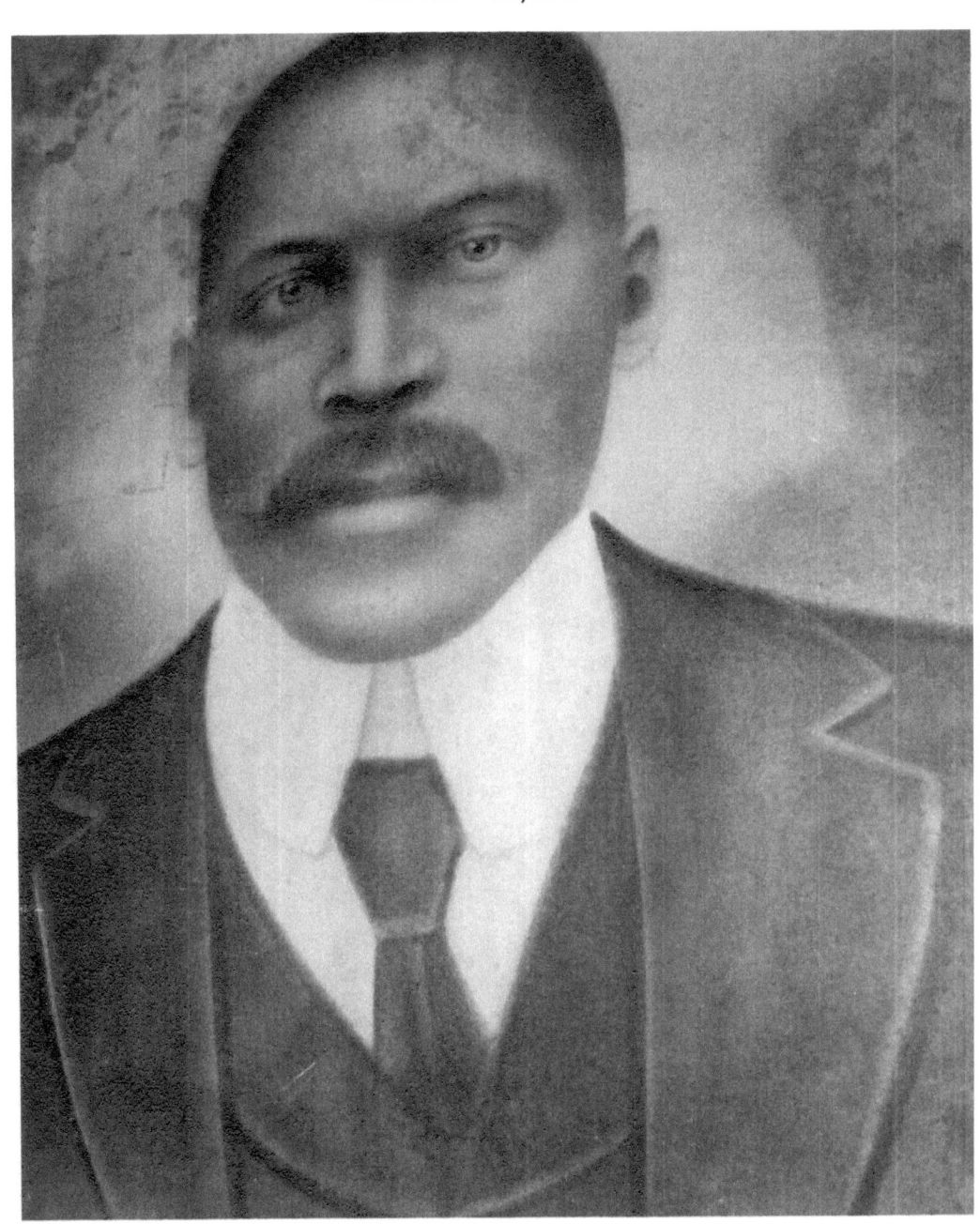

An Advertisement placing slaves of Jonathan Hardin for sale. Allen was the brother of Evaline Hardin who married James M. Jones.

Lance J. Gosnell <ljgosnell@lanceyjgosnell.com>

To Marion Hill

Valuable Negroes for Sale.

BY the mutual consent of the heirs interested in the estate of Russell Greenhaw, deceased, the following negro property (a mother and her children), will be sold to the highest and best bidder for cash in hand, on Monday, 14th day of March next, (it being the first day of the Conway county Circuit Court), at the town of Springfield, the seat of justice of said county, between the hours of 10 and 3 o'clock of that day, to wit:

Hannah, aged 41 or 42 years.
Allen, " 34 " 35 "
Albert, " 22 " 23 "
Evaline, " 18 " 19 "

All communications in relation to the above property, addressed to the undersigned, at Cadron P. O., Conway county, Arkansas, will receive prompt attention.

JONATHAN HARDEN.

ALLEN HARDIN

PRIVATE in the 88TH UNITED STATES COLORED INFANTRY COMPANY H

HOMESTEADER

Final Homestead Proof required under Section 2291 of the Revised Statutes of the United States.

WE, Eveline Janes & Hannah Gordan, do solemnly Swear that we had known Allen Harden for over 30 years last past; that he was the head of a family consisting of a Wife and _____ a citizen of the United States; that he was an inhabitant of the E½ of S.E.¼ of Section No. 7 in Township No. 6 N of Range No. 14 W, and that no other person resided upon the said land entitled to the right of Homestead or Pre-emption.

That the said Allen Harden entered upon and made settlement on said land on the 11 day of August, 1870 and has built a house thereon and Albert G. Gratton is the lawful administrator of the Estate of Allen Harden

and has lived in the said house and made it his exclusive home from the 11th day of August, 1870, to the time of his death and that he has since said settlement, plowed, fenced, and cultivated about 10 acres of said land, and has made the following improvements thereon, to wit: Built Cane Cribb & Smoke house and planted 250 fruit trees

Witness to L. B. Carles Eveline her ✗ mark Janes
both marks Hannah her ✗ mark Gordan

I, H. H. Ratians, do hereby certify that the above affidavit was taken and subscribed before me this 15th day of Oct, 1877.

H. H. Ratians, County Clerk

WE CERTIFY that Eveline Janes & Hannah Gordan, whose names are subscribed to the foregoing affidavit, are persons of respectability.

H. H. Ratians County Clerk, Receiver

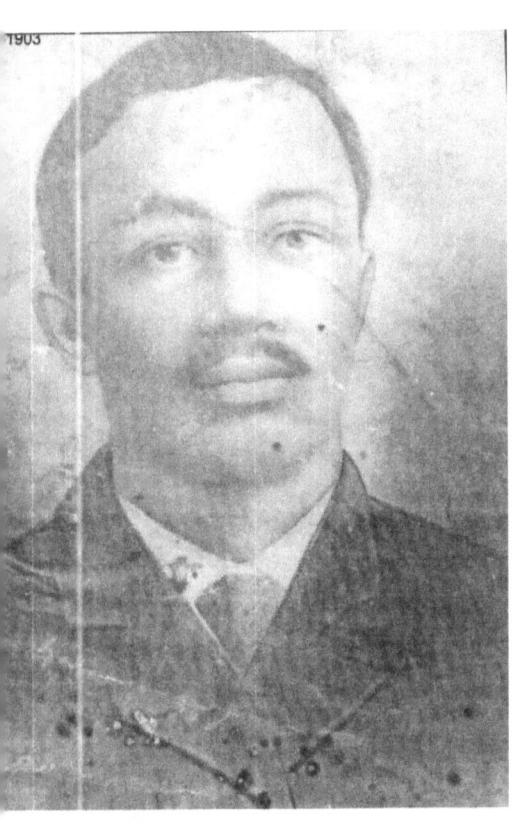

Pencil Sketch

LEN ADERSON JONES
(Brother to William Henry Jones)

WILLIAM HENRY JONES
and Wife NANCY
BIRTS JONES

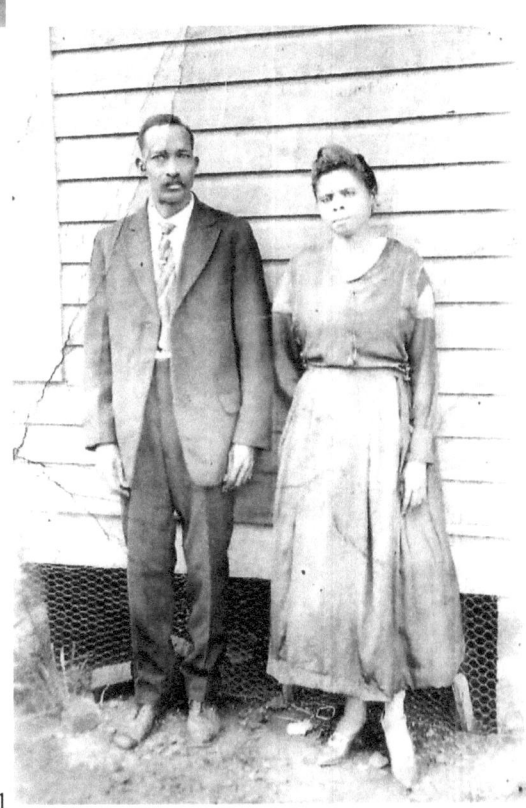

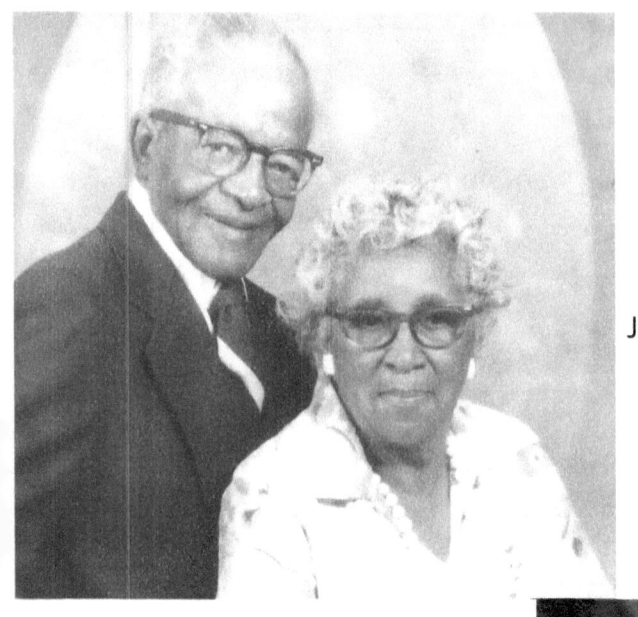

HENRY SIMPSON
and wife KATIE
JONES SIMPSON (Sister of Rev.
George W. Jones)

Rev. George W. Jones
(Pastor of Greater Mt. Sinai
Baptist Church of Chicago, IL)

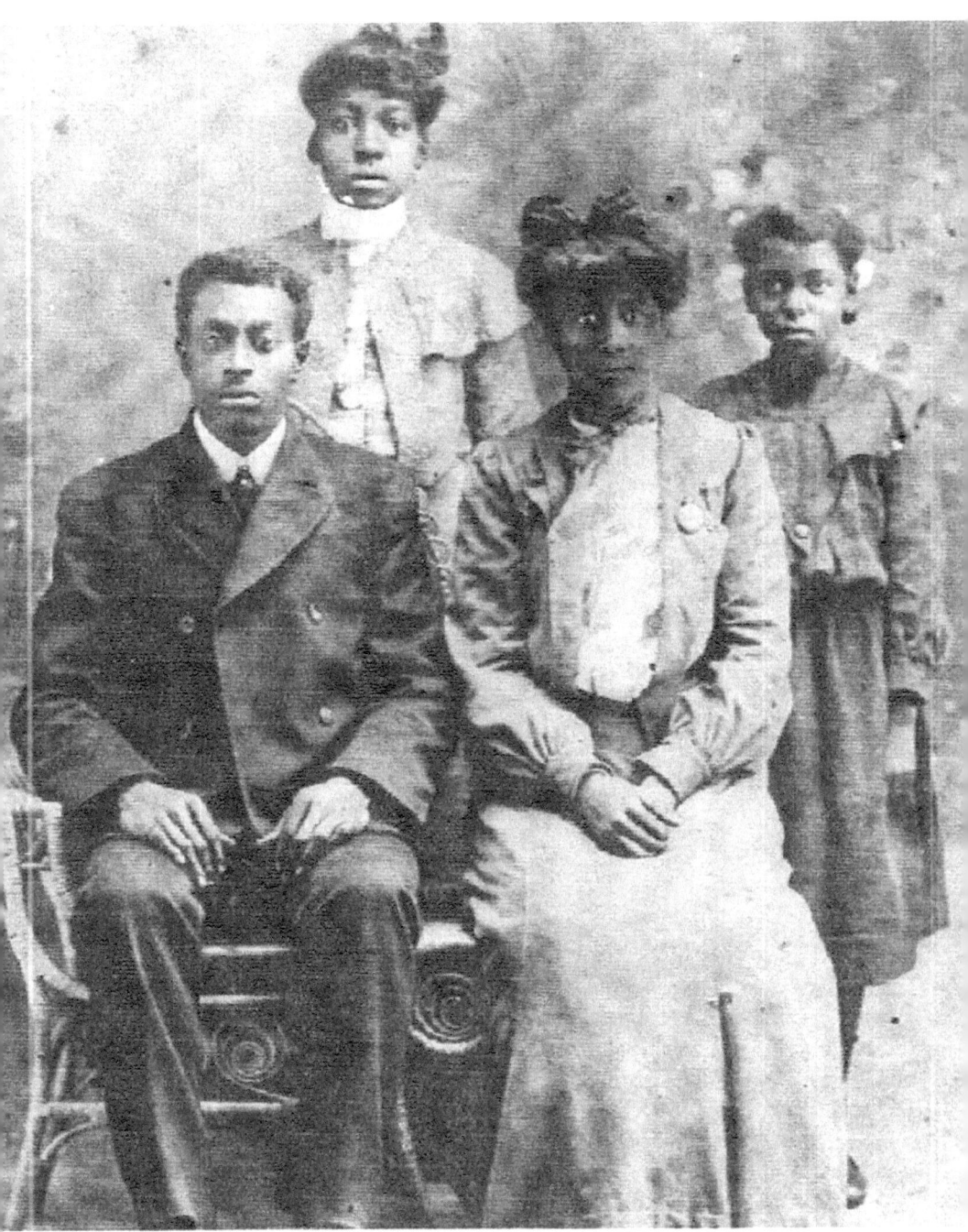

LEN ADERSON JONES

(1864 AR - 1908 AR)

LUCY JONES
and Children
SARAH JONES
LAXACANA

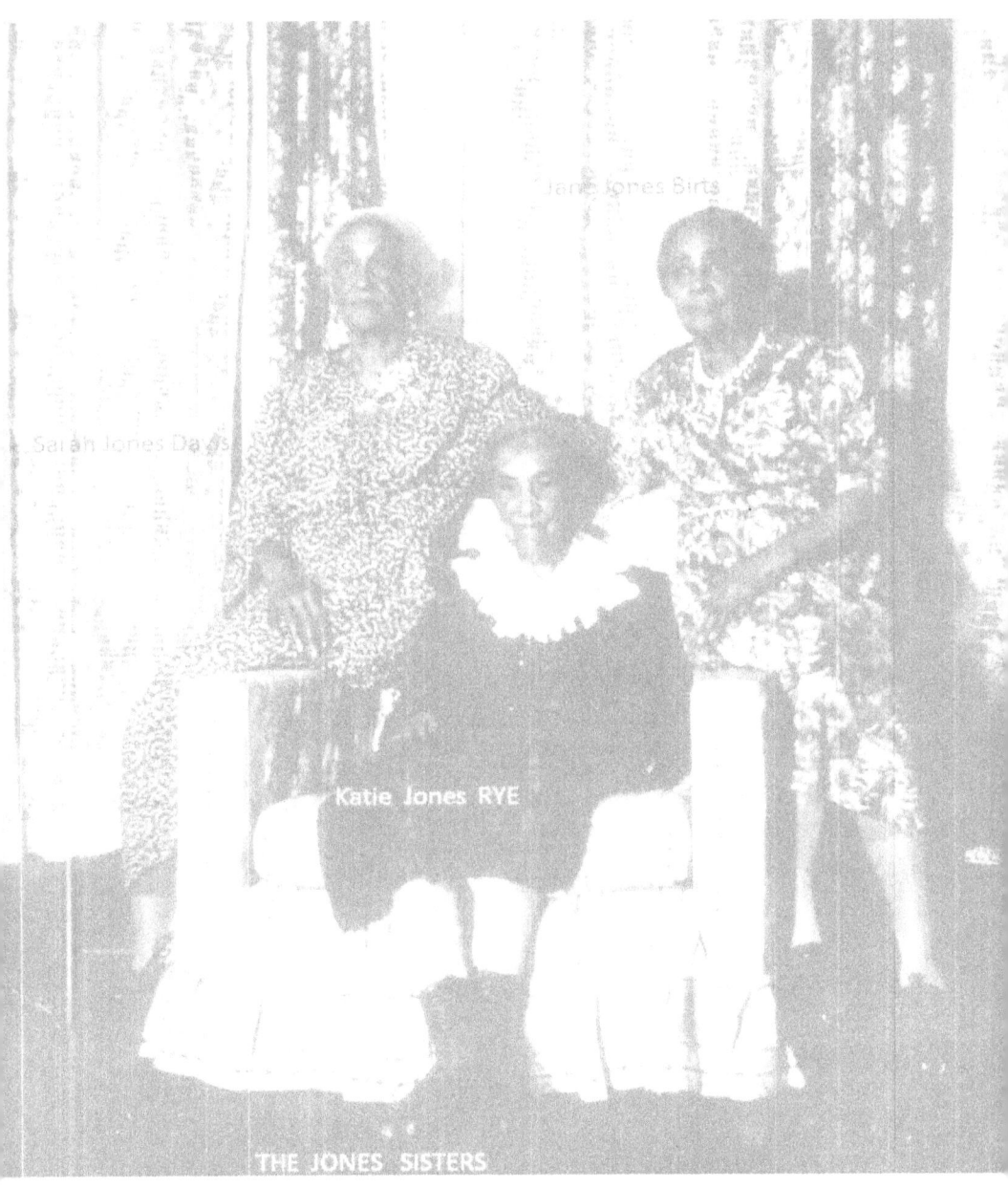

THREE SISTERS

SARAH JONES DAVIS
1869 AR- 1962-IL

HANNAH CATHERINE
JONES RYE
1855 AR - 1949 IL

JANE JONES BIRTS
1870 AR- 1963 IL

HANNAH CATHERINE JONES JACKSON-RYE (1855 AR-1949 IL)

Hannah was born to James Madison Jones and Eveline Hardin Jones in East Fork Township, Conway County, Arkansas. Katie, as she was called, recounts her early years as a slave in the Slave Narratives of the 1930's. A copy of her interview can be found in the book, BEARING WITNESS, Memories of Slavery listed under Katie Rye of Faulkner County, Arkansas.

Katie married early to William Jackson, and to this union was born William Jackson Jr. their only child. At some point between 1880 and 1890, William (her husband) died.

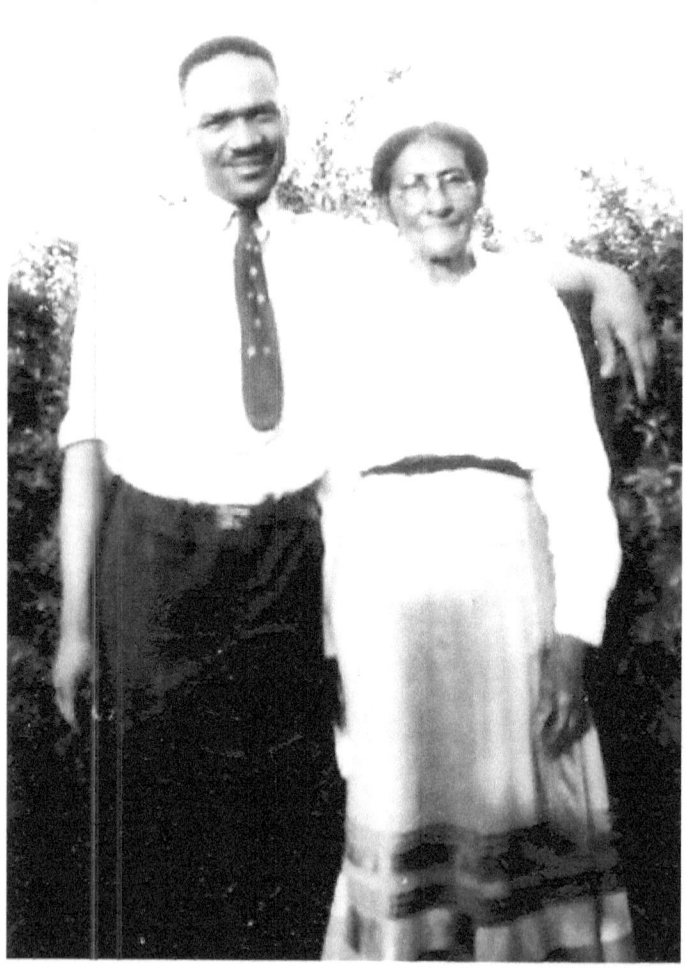

Hannah Catherine
Jones-Rye
1855 AR-1949 IL
Daughter of James
Madison Jones
Standing with Grandson
Herman Jackson

JONES

Helen Jackson Mayo
Granddaughter of
Hannah Jones-Rye

William Jackson
Son of Catherine Jones Rye
Father of Herman Jackson and
Helen Jackson Mayo

DAVIS

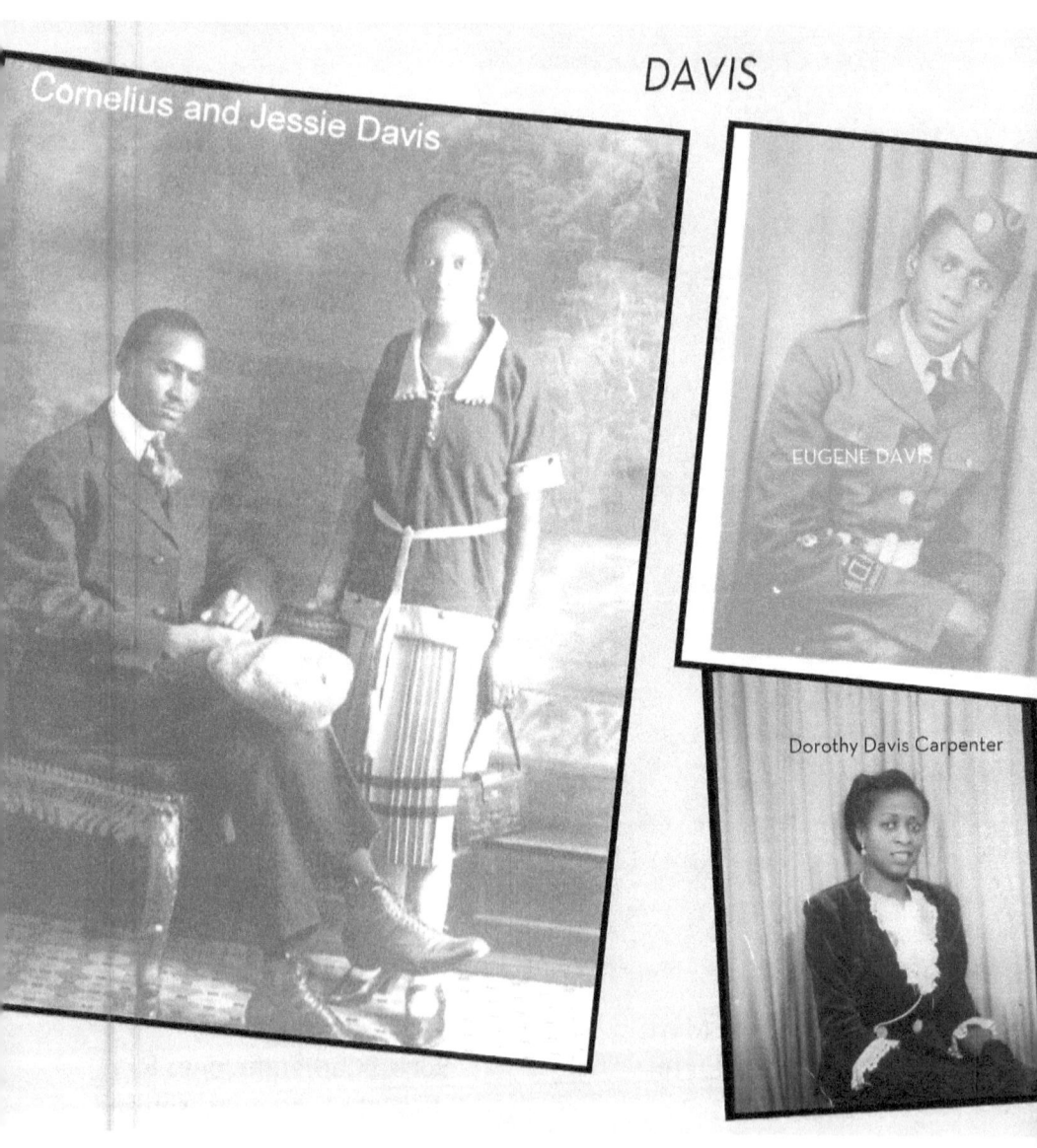

Cornelius and Jessie Davis

EUGENE DAVIS

Dorothy Davis Carpenter

Catherine Eloise Davis

1933 – 1984
Robert Lee Davis

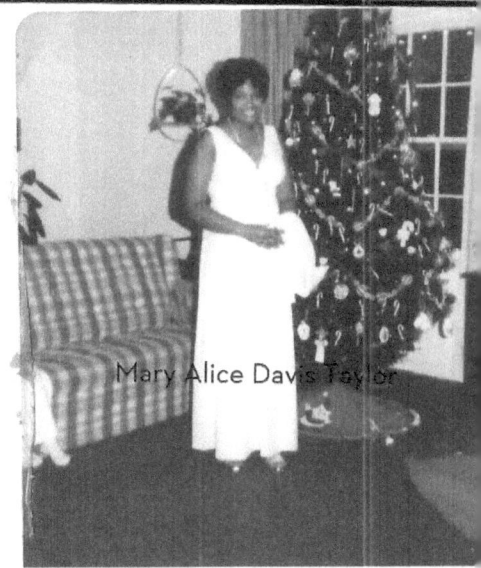

Mary Alice Davis Taylor

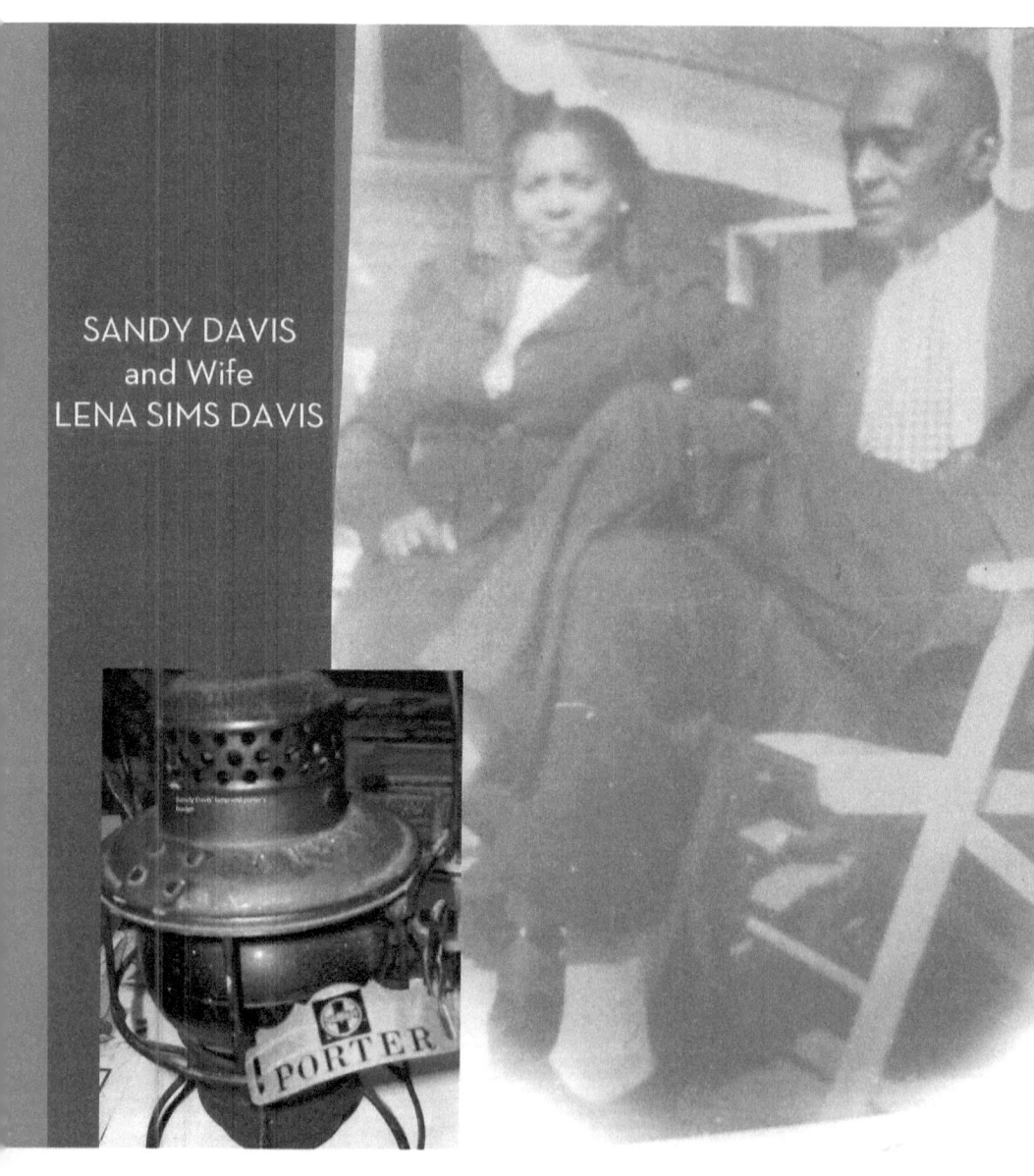

SANDY DAVIS
and Wife
LENA SIMS DAVIS

Thomas Jefferson Davis was born (according to family Bible records) January 12, 1862 to James Madison Davis and Ma Davis in Holly Springs, MS.

He along with his brother Wyatt and two sisters Mattie and Clara are accounted for in the DeSoto County, MS census of 1870 residing with their mother Mary Davis Coppage, their Stepfather Stephen Coppage, and several other children with the Coppage surname.

Ten years later Thomas and Wyatt are enumerated with their father James Madison Davis, his second wife Janie Booker Davis, and a stepsister Lucy Davis and stepbrother Madison Davis in the 1880 census of Faulkner CO, AR

Thomas married Elizabeth Nelson in 1895 and to this union three children Clyde, Ethel, and Horace were born. The census data of 1900 and of 1910 indicate that Thomas worked as a school teacher for several years before moving his family to Chicago where he is listed in the 1930 census as a bondsman working from his own office. He and his family lived at 3828 S. Elmwood.

Thomas Jefferson Davis' certificate of death shows chronic nephritis and myocarditis as the principal causes of death which happened on March 3, 1931. He is buried in Lincoln Cemetery.

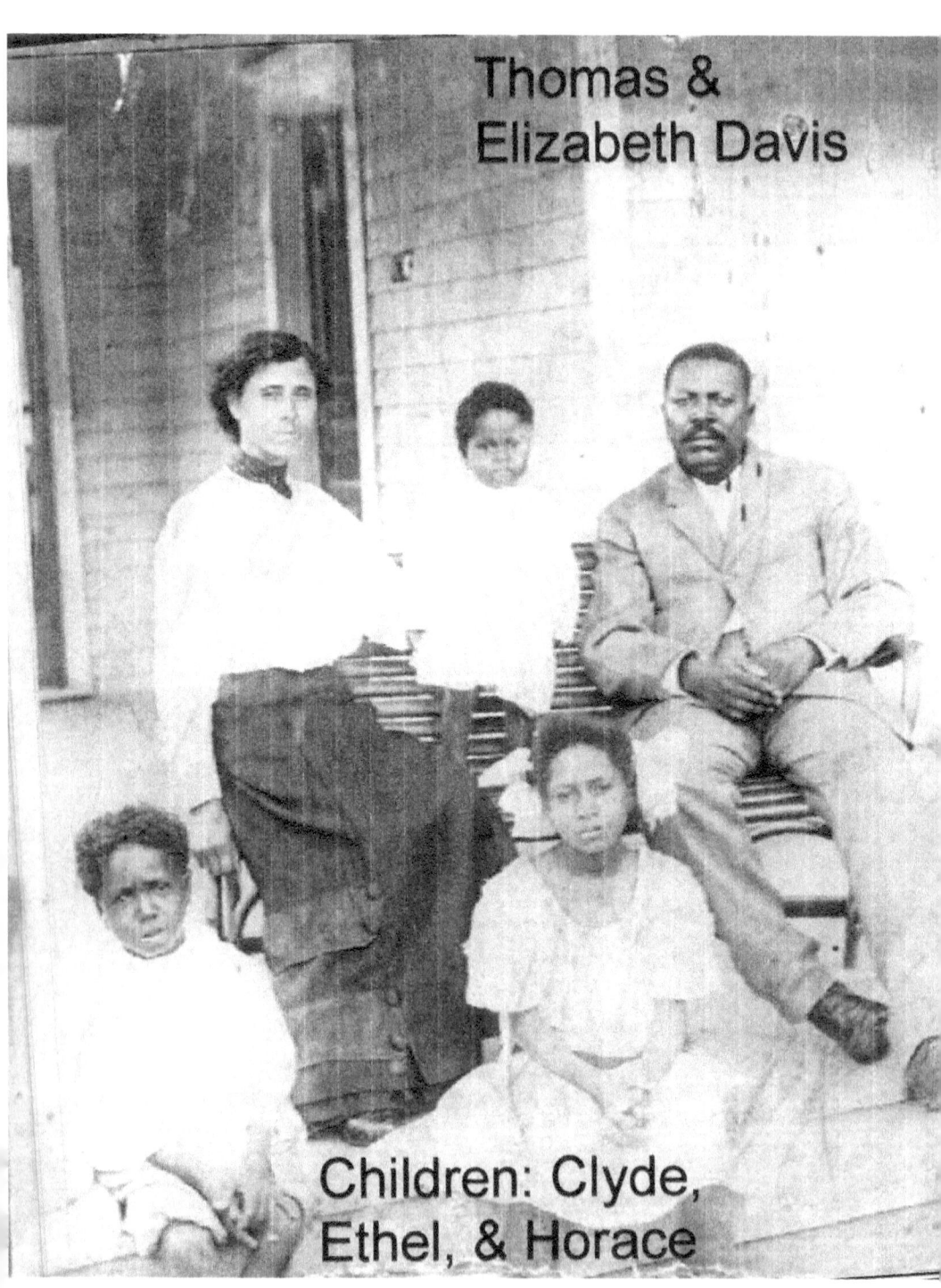

THE ROBINSON FAMILY

FRANK ROBINSON (1851 NC -1934 AR) was born in Mecklenberg County, North Carolina, The census of 1870 lists Frank with a brother Andy Robinson and a sister Dora Green.

Frank Robinson married Elizabeth Ingram of South Carolina in 1877. To this union were born four children: John, William, Allie, and Ollie. In the early 1890's, Frank Robinson, his family and two other families, (Winklers and McDowells), moved from Charlotte, NC to Pulaski County, Arkansas. Frank acquired land in the Cato township of Pulaski County and there raised his family.

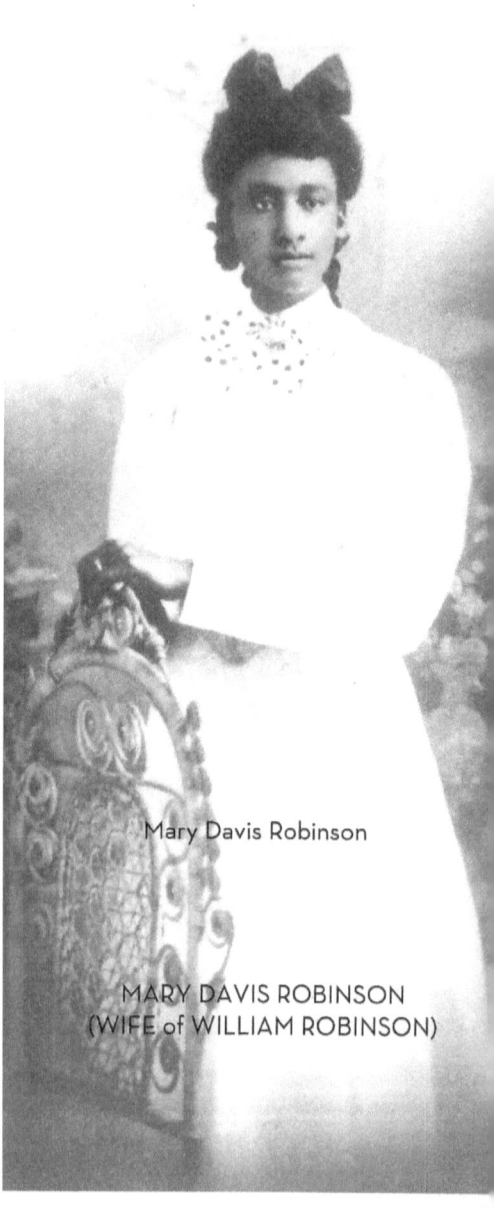

WILLIAM ROBINSON (1880 NC - 1966 IL)

William Robinson

Mary Davis Robinson

MARY DAVIS ROBINSON
(WIFE of WILLIAM ROBINSON)

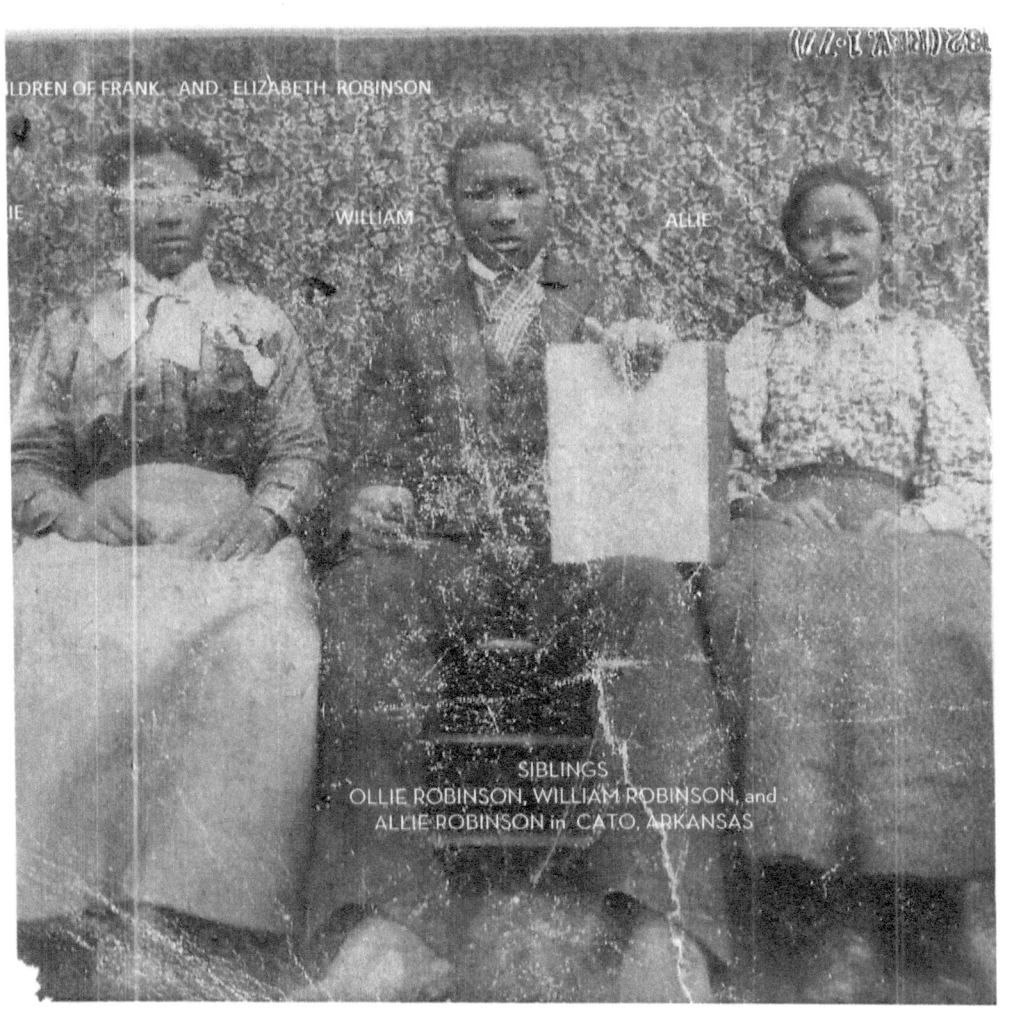

William and Mary Davis Robinson with their Nine Children in Chicago, IL

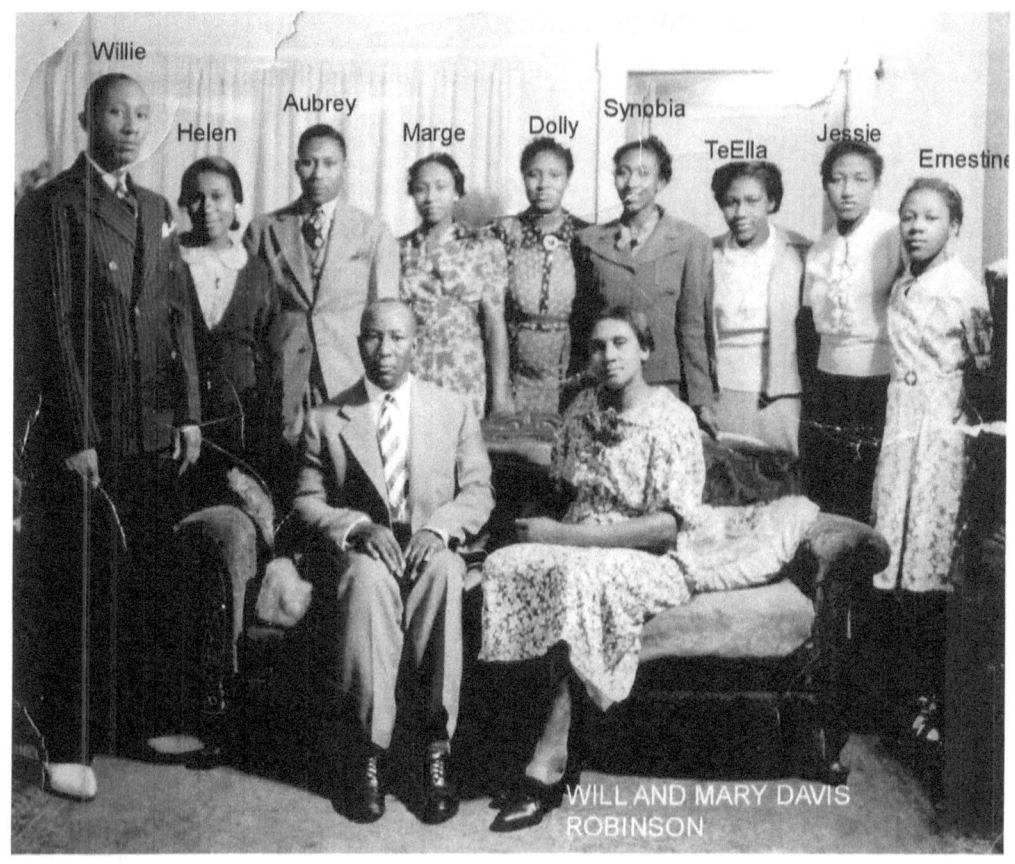

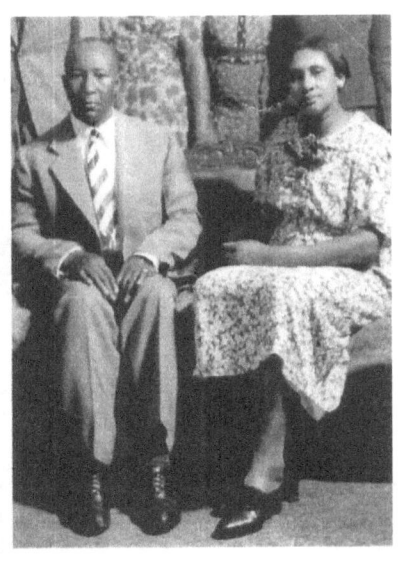

William Robinson was born in 1880 to Frank Robinson and Elizabeth Ingram Robinson in Charlotte, North Carolina. Census records of 1870 enumerate Frank and two of his siblings (Ande Robinson and Dora Green) living in Mecklenburg County on the farm of one Jordan Carreton. From Frank came the family story that after freedom came, some of the Robinsons changed their name from Green to Robinson. Green was the name of the former master, and Robinson was the name of his son-in-law. Elizabeth was listed in the 1870 census living with her parents Wiley and Millie Ingram in Cane Creek, Lancaster County, South Carolina.

According to one of Frank's granddaughters, Frank Robinson and his family, along with two other families, the Winklers and the McDowells, moved by train from North Carolina to Arkansas during the 1890's. The Robinson family can be found listed in the 1900 census of Arkansas living in Pulaski County in the town of Cato. The land which Frank purchased and farmed stayed within the family until recently.

By the 1920's, two Robinson sisters (Ollie and Allie) had married two Watson brothers (John and Harvey). To those two couples were born a total of seventeen children, many of whom have children and grandchildren now living in Arkansas, Arizona, and California.

William, in 1923, moved his family to Chicago. His daughter Helen remembers the move which involved her mother, father, and eight children. She speaks of the lunch her mother packed, the suitcases, and of how, after reaching a certain point in their journey, they moved from one coach to another. She tells us that her father became angry when he was directed to a separate coach to smoke, while the white men went to another. After all, he himself was a railroad employee, but he still received the Jim Crow treatment. Helen makes us laugh and cry when she describes the family of eight children and two adults packing themselves into one cab to make the long trip from the train station to the Morgan Park neighborhood where they would be staying with Helen's grandparents.

William continued his membership in the Methodist church by joining with the Arnett Chapel A.M.E. congregation in Morgan Park. He served as a class leader until he became ill with a stroke.

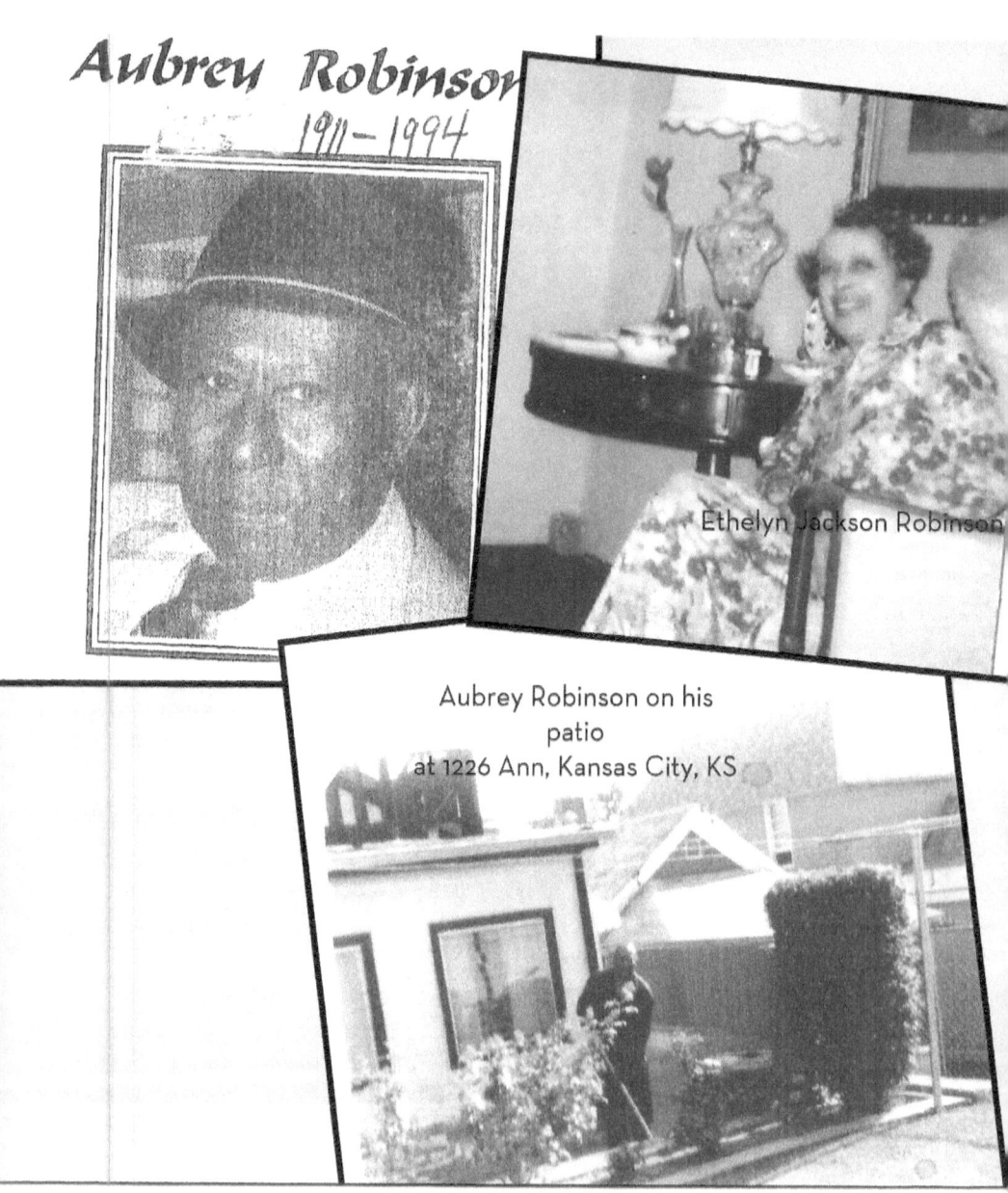

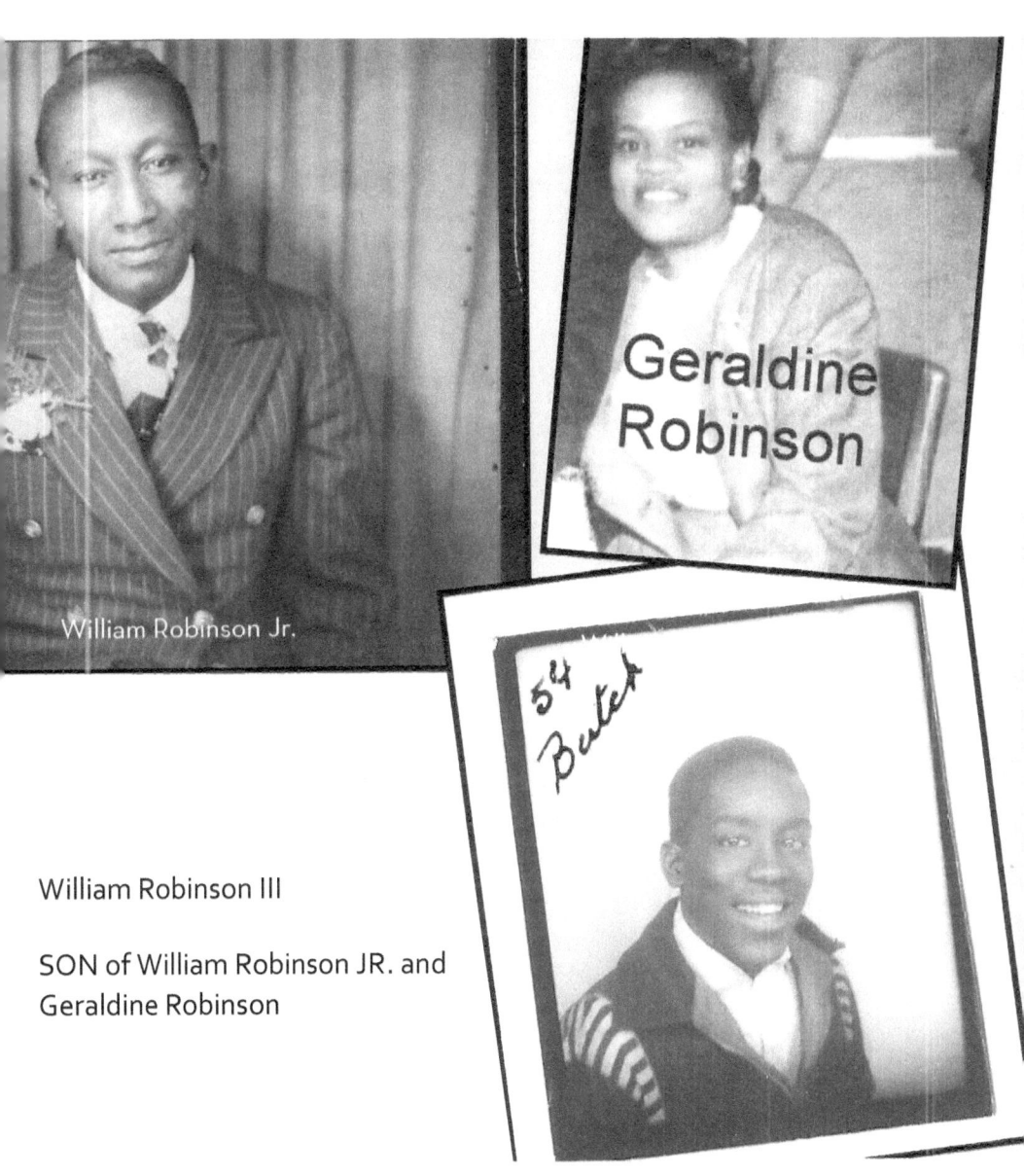

William Robinson III

SON of William Robinson JR. and Geraldine Robinson

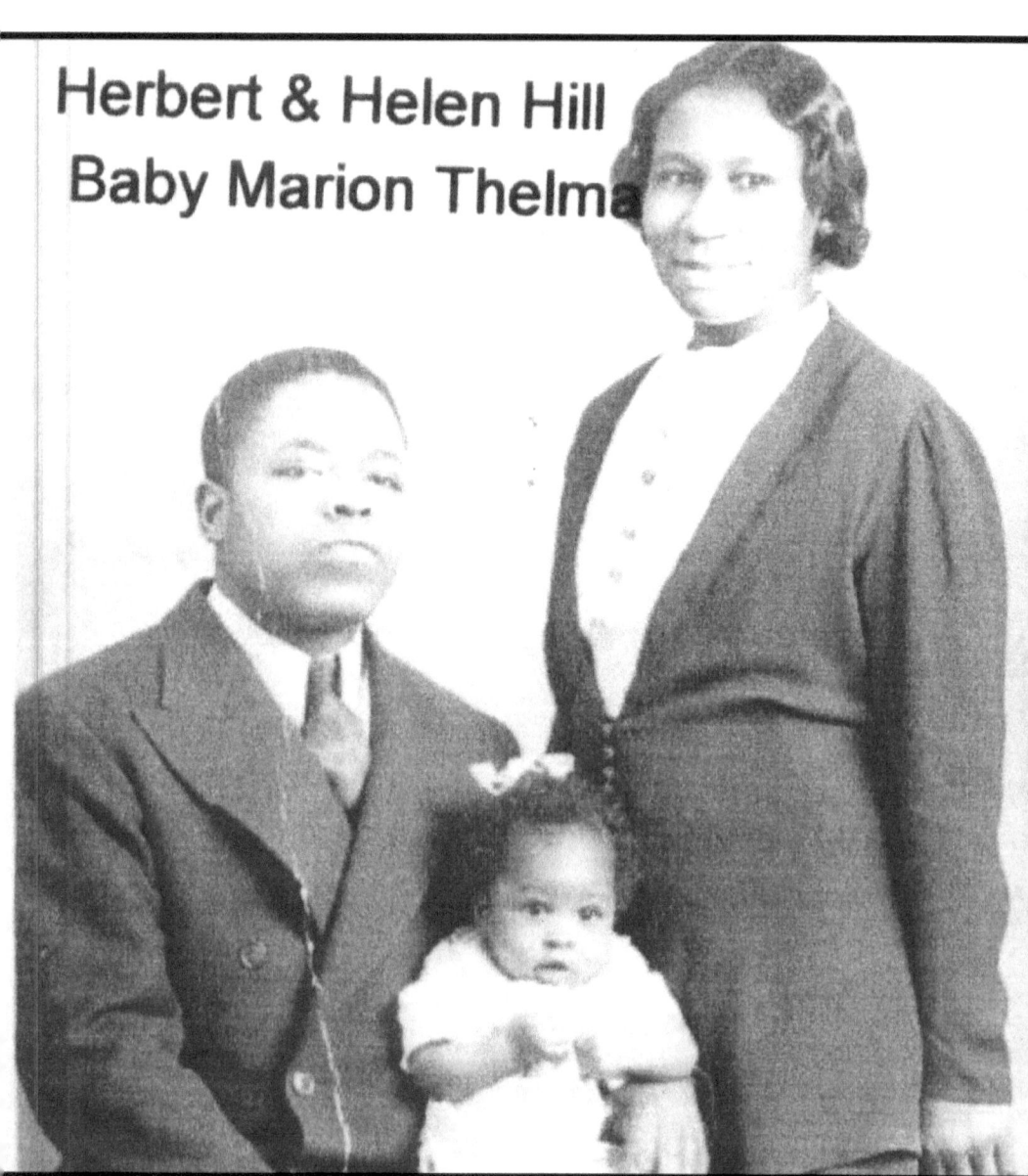

Ken Hill and
Mom Helen Hill

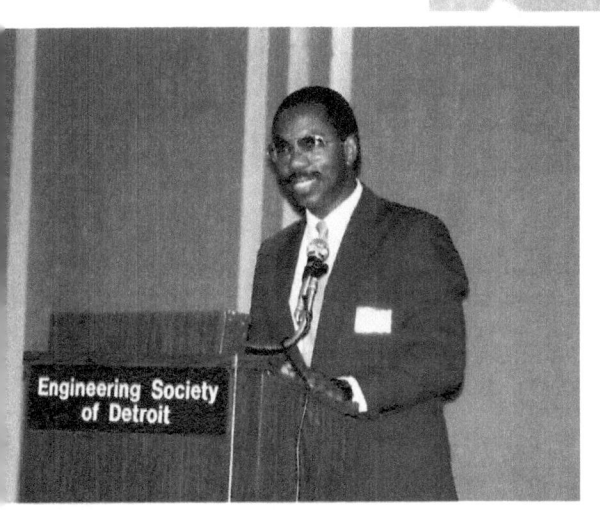

KENNETH HILL (CIVIL ENGINEER and Founder of DAPCEP and CHI S and E)

AUNT
ALLIE ROBINSON WATSON

NIECE
HELEN ROBINSON HILL

CERTIFICATE OF ANCESTRY

African Ancestry hereby certifies that

Helen E. Robinson-Hill

Shares Maternal Genetic Ancestry with

Temne people living in Sierra Leone

Based on a MatriClan™ analysis performed on

May 9, 2011

Rick Kittles, Ph.D.
Scientific Director

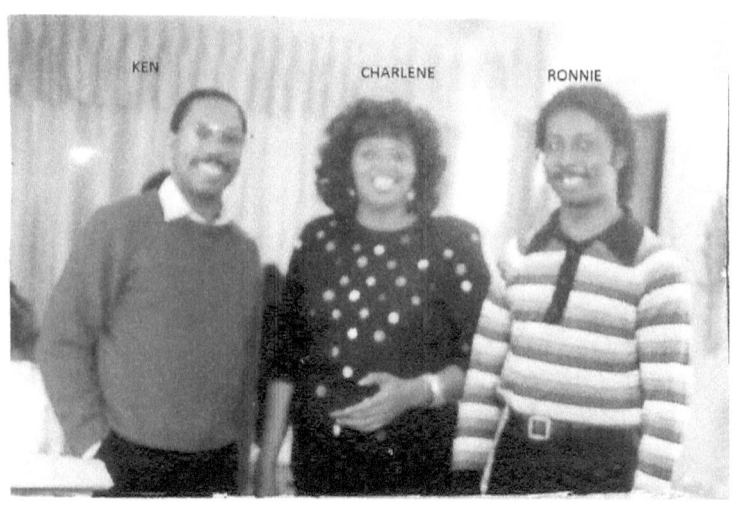

COUSINS

KENNETH HILL, CHARLENE MCLAUGHLIN and RONALD REDDITT

SIBLINGS

KENNETH HILL and MARION HILL

HERDYSENA HILL CRAVEN

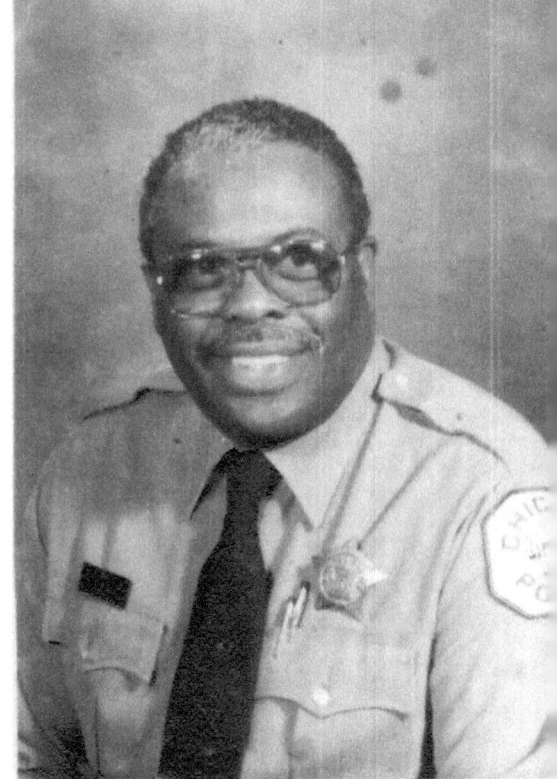

HERBERT HILL JR.

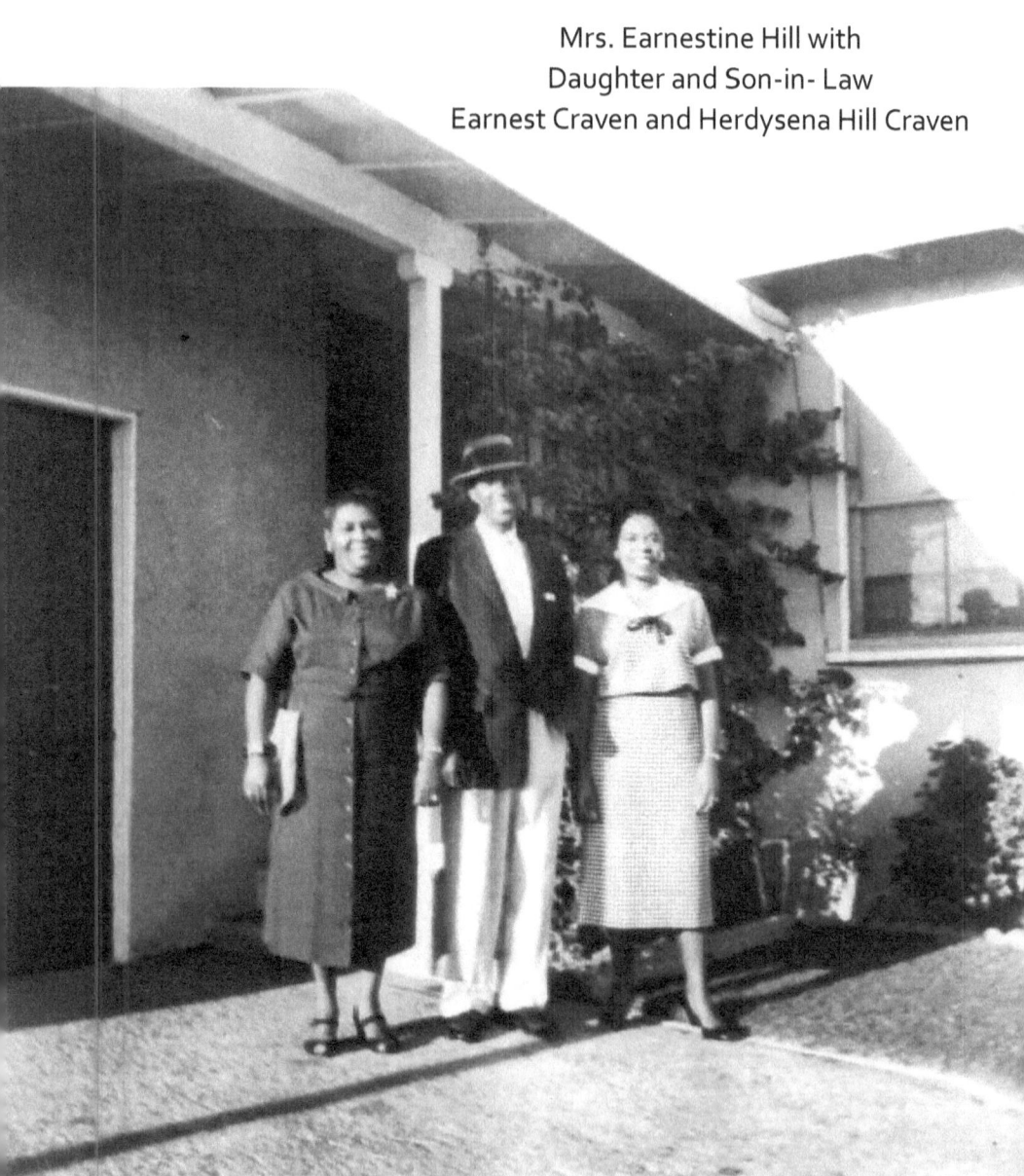

Mrs. Earnestine Hill with Daughter and Son-in-Law Earnest Craven and Herdysena Hill Craven

BARBARA GRAVES
TOWNSEND
Daughter of Frenchie Graves
and Great granddaughter
of Jane JONES Birts

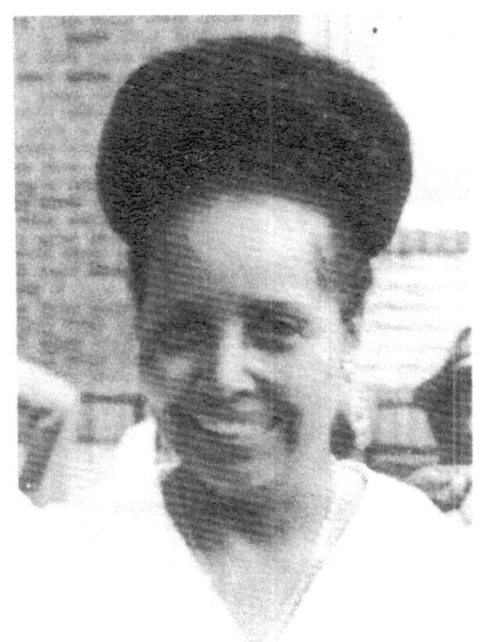

Frenchie E. Graves

COUSINS
KWESI HILL and CHARLENe
MCLAUGHLIN

AFENI HILL
(Daughter)

KEN HILL
(Father)

FATHER and DAUGHTER

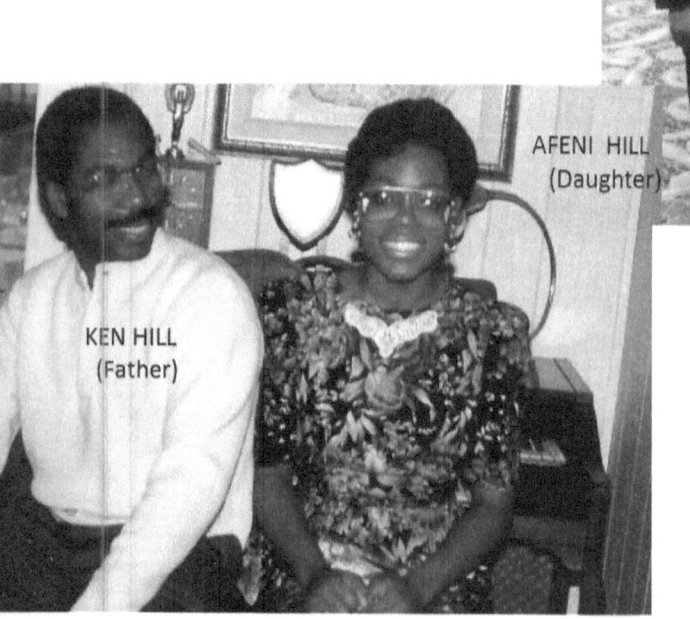

COUSINS

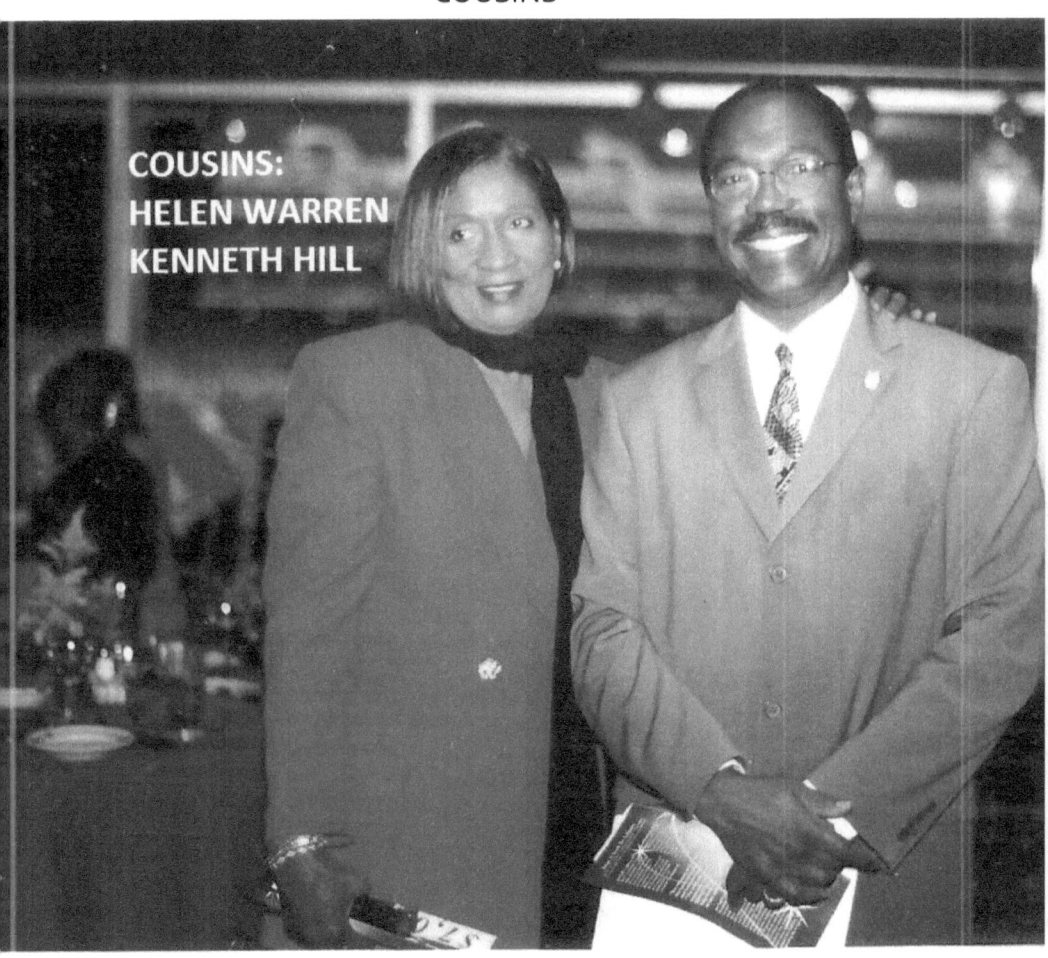

COUSINS:
HELEN WARREN
KENNETH HILL

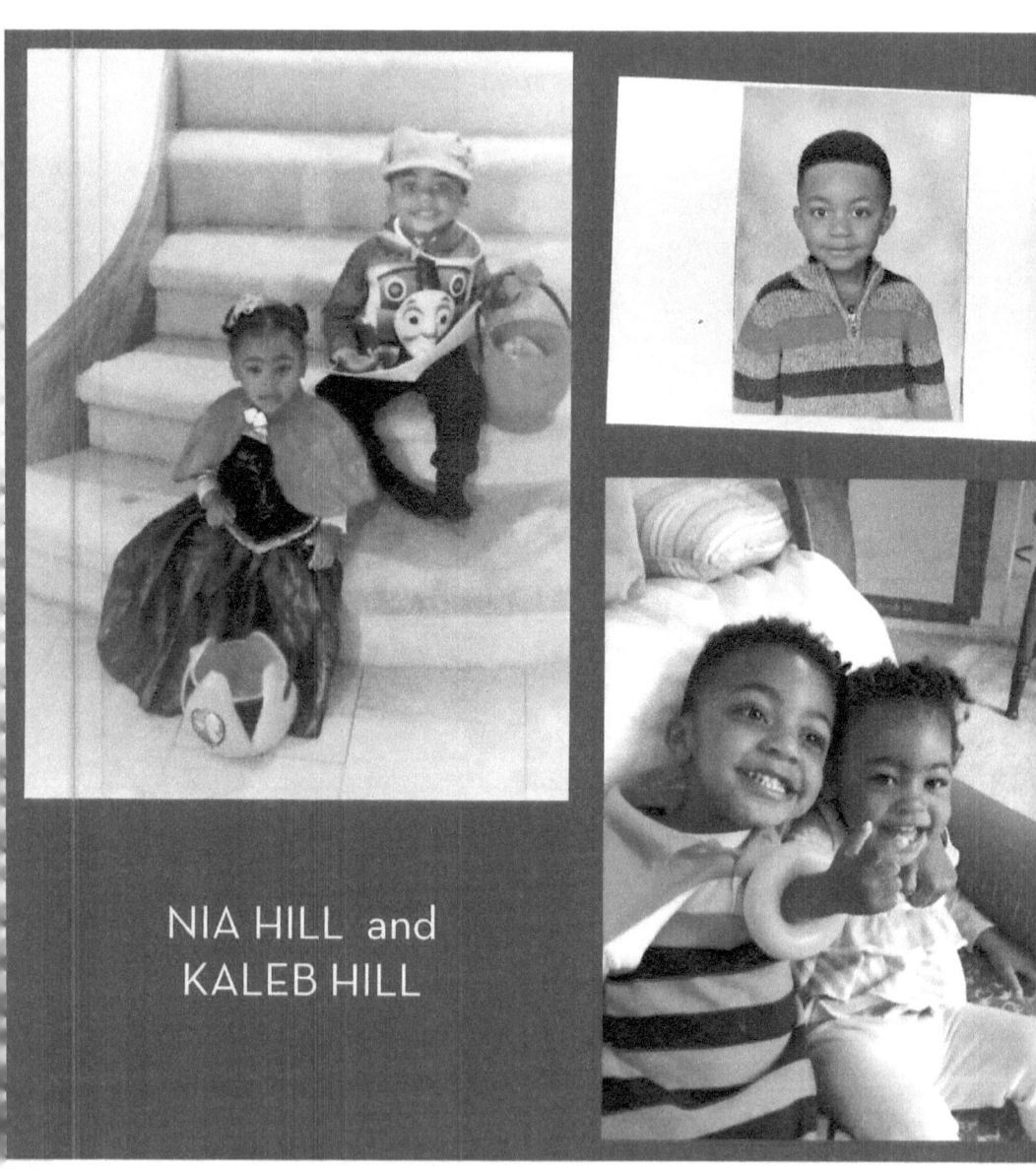

NIA HILL and KALEB HILL

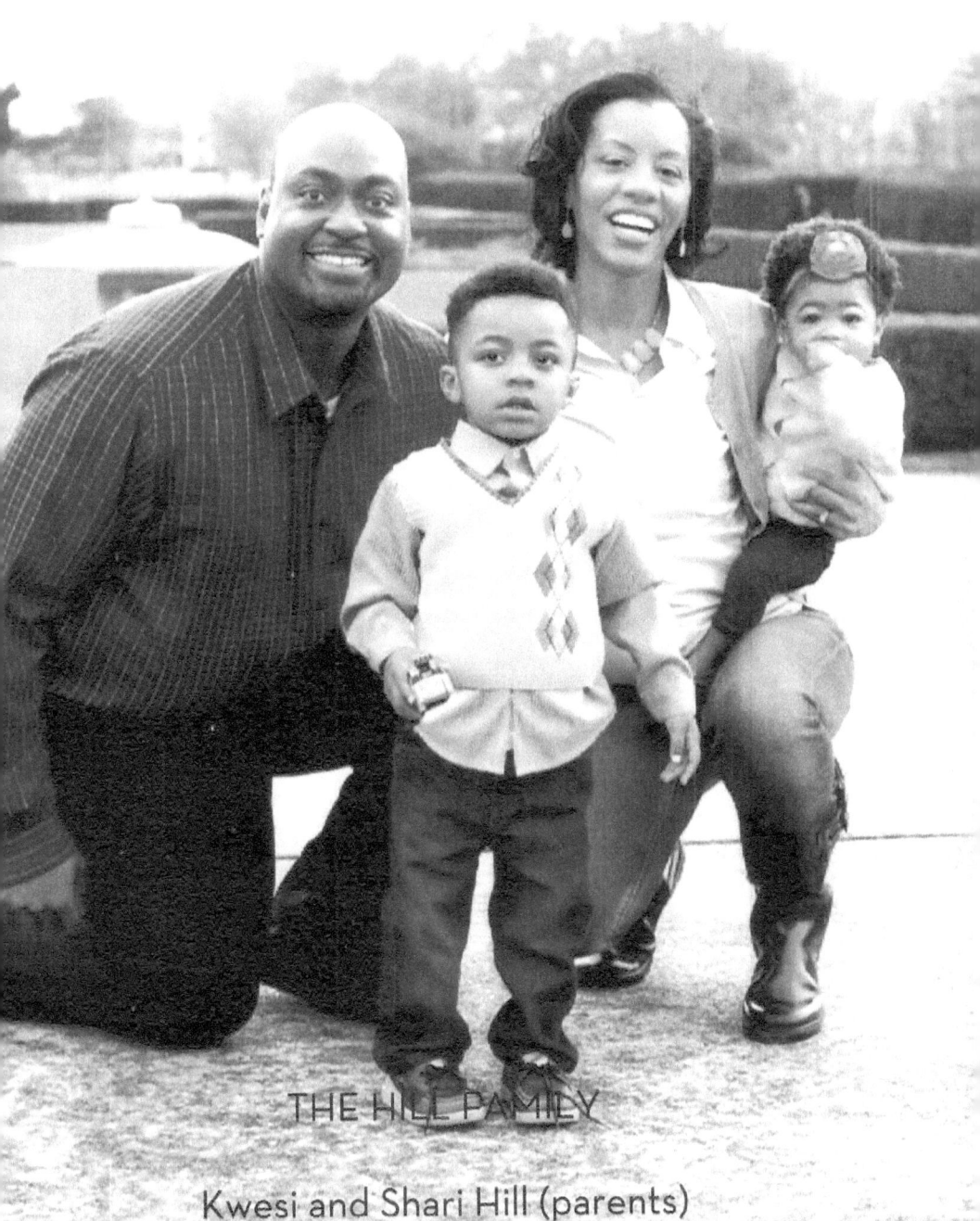

THE HILL FAMILY

Kwesi and Shari Hill (parents)

JESSIE MCLAUGHLIN

WALTER MCLAUGHLIN

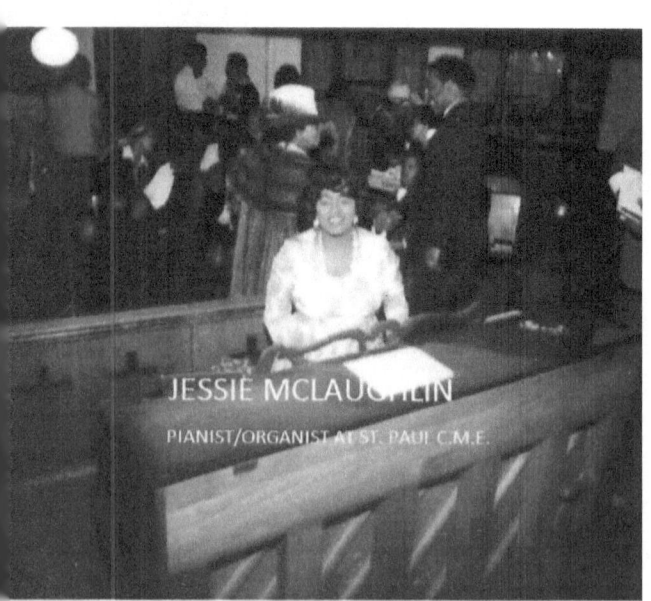

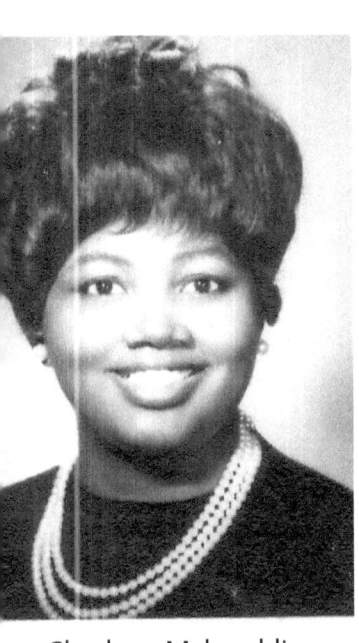

Charlene Mclaughlin
(Daughter)

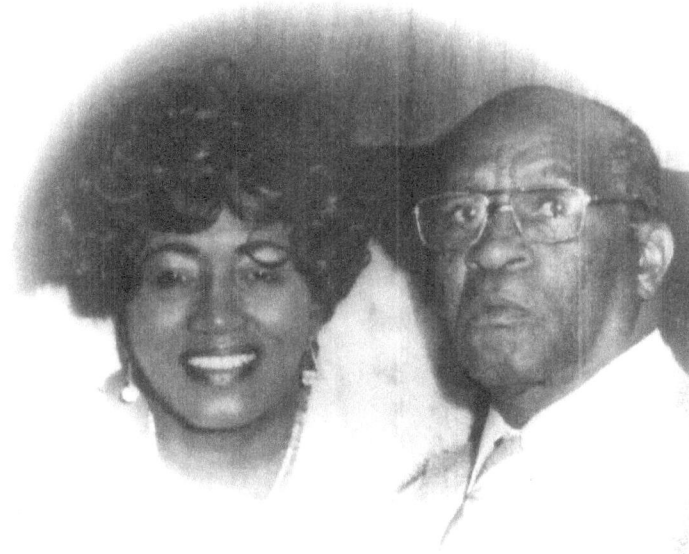

MR. AND MRS. WALTER MCLAUGHLIN

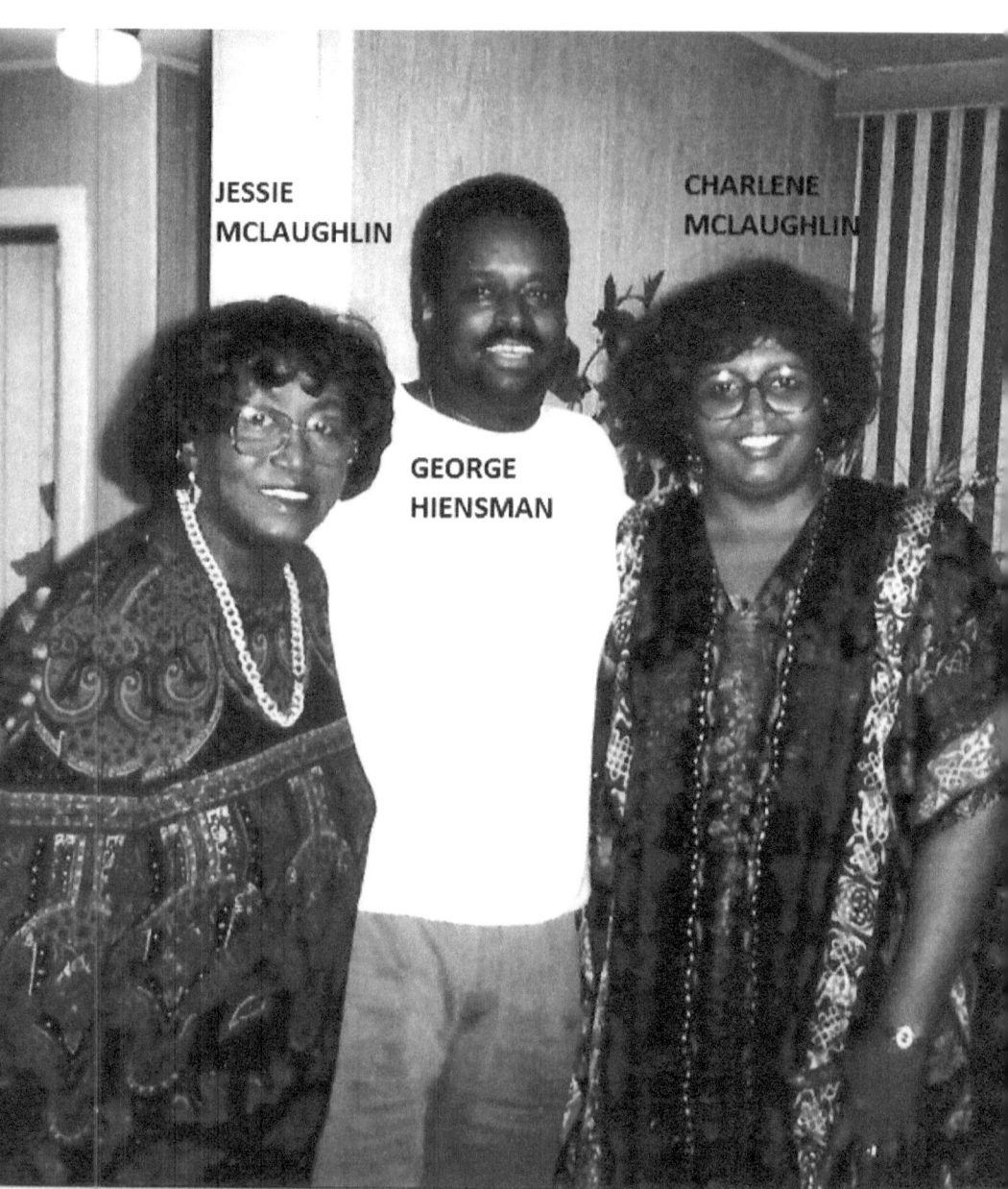

COUSINS

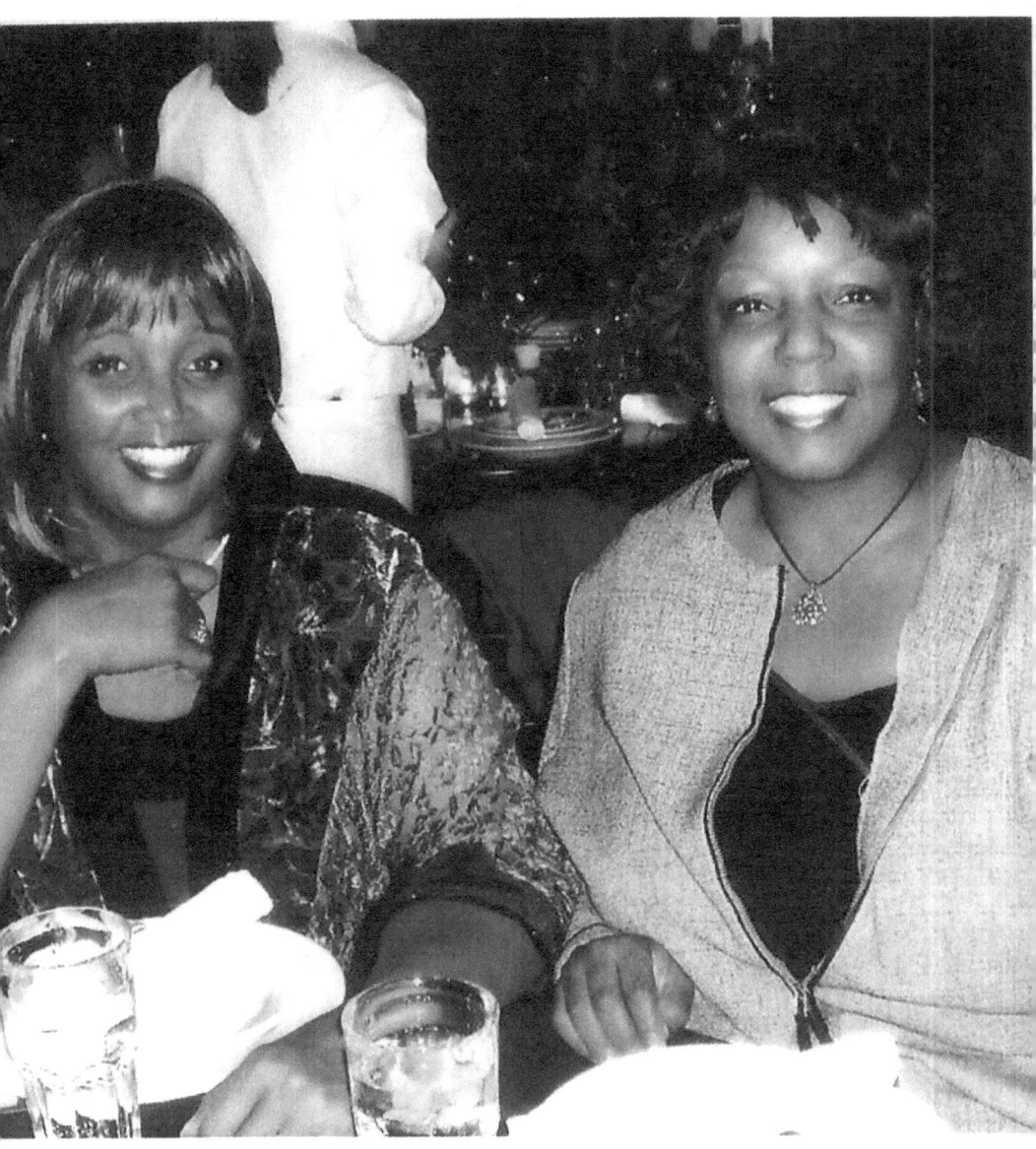

CHARLENE MCLAUGHLIN
and LYNN WATSON CHEEKS

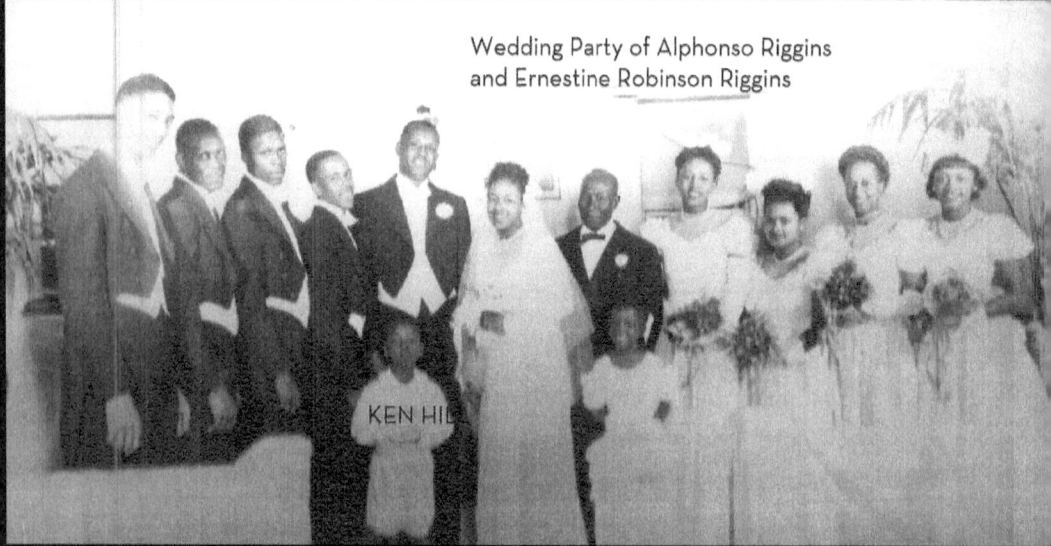

Mary Davis Robinson's 90th Birthday

Wedding Party of Alphonso Riggins and Ernestine Robinson Riggins

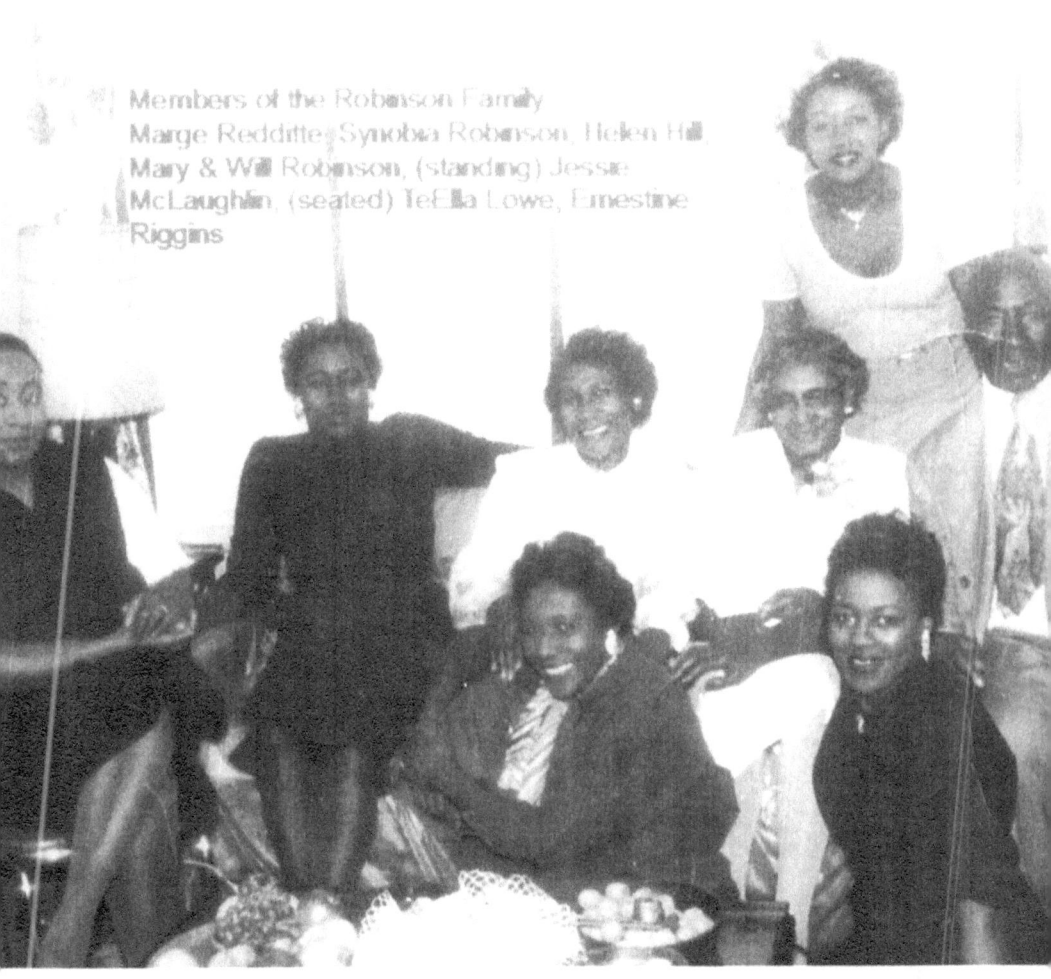

Will and Mary Davis Robinson and Family

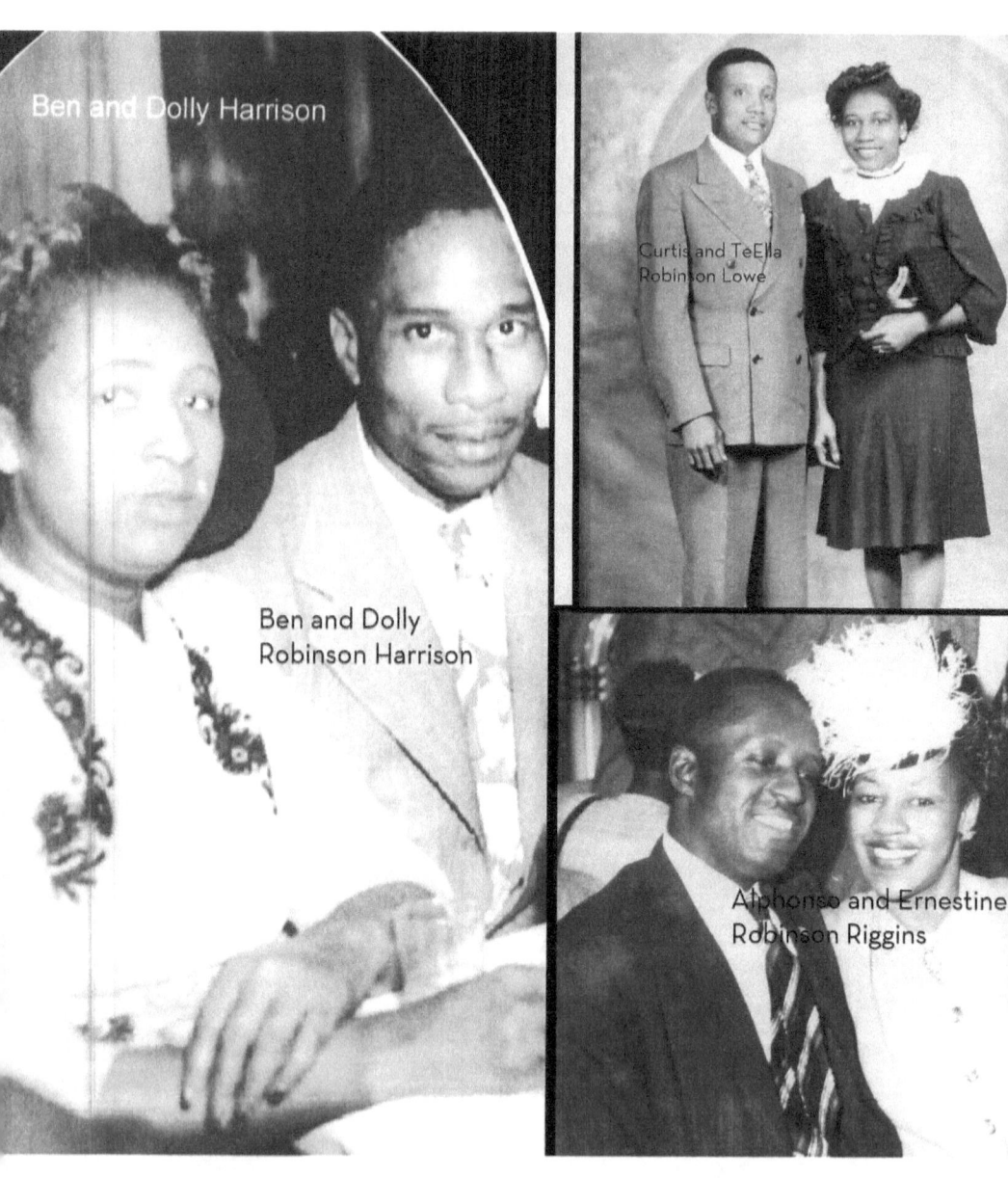

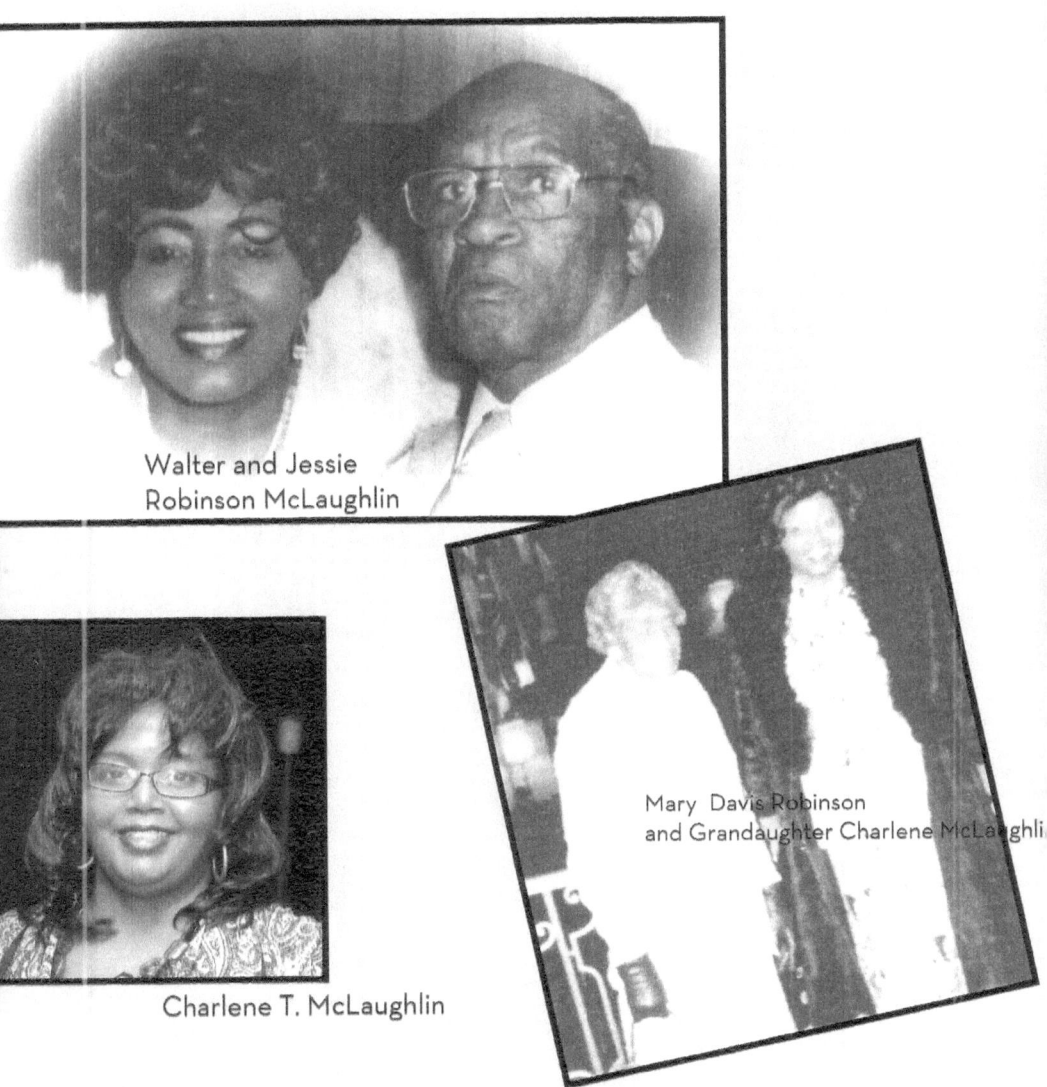

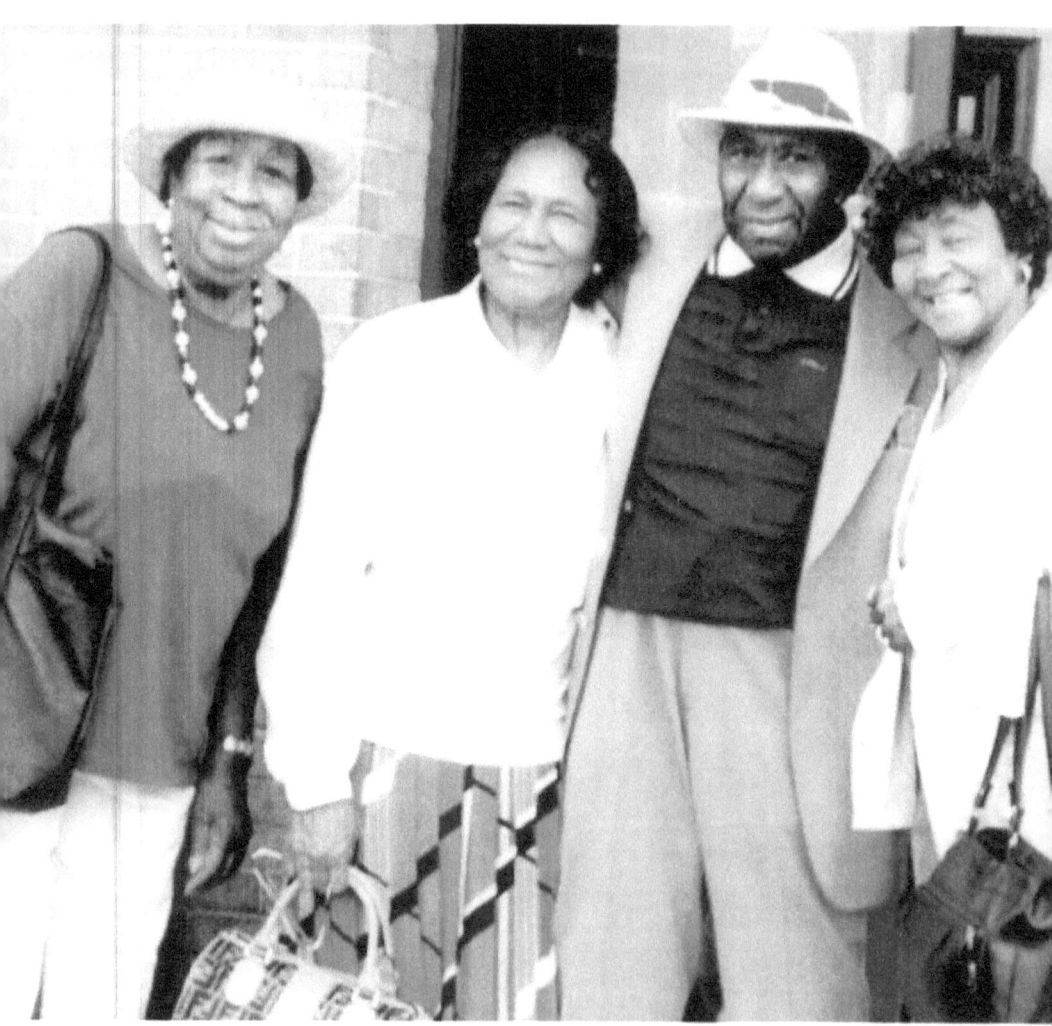

Dolly Harrison, Helen Hill, Aubrey Robinson, Marguerite Redditte
SIBLINGS

Ronald and (Wife) Marie Redditte

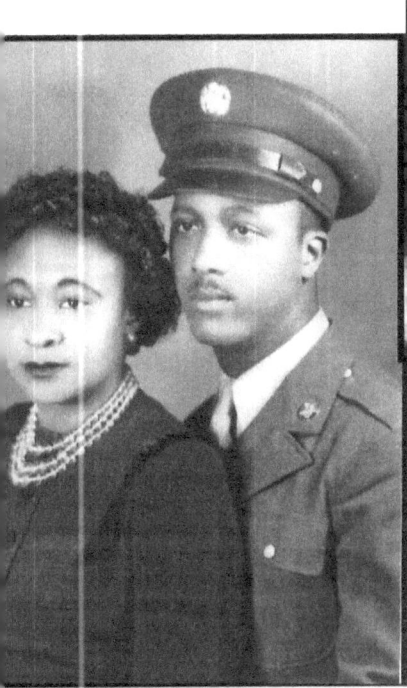

Bill and Marguerite Redditte

Marguerite Redditte and son Ronald Redditte

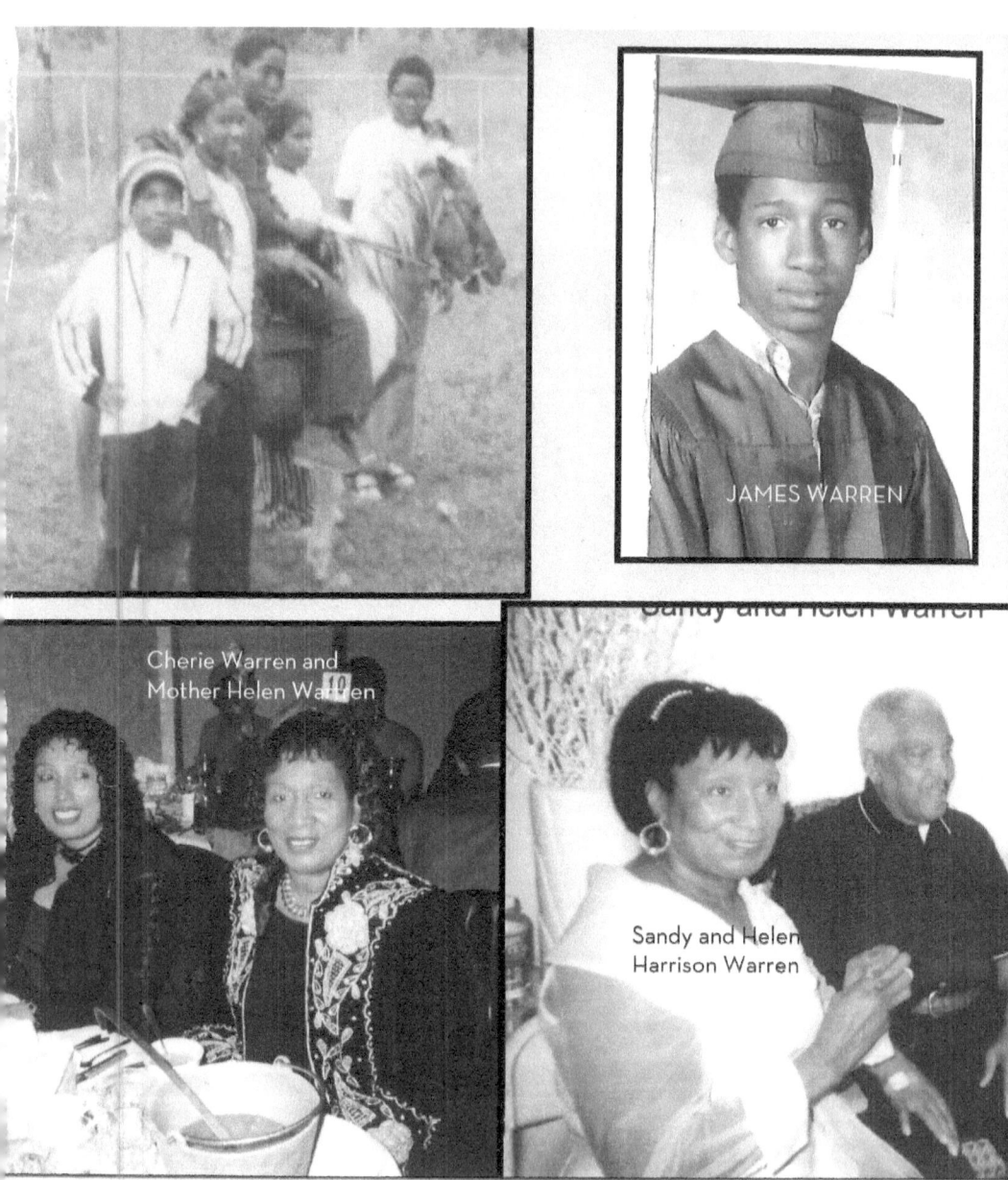

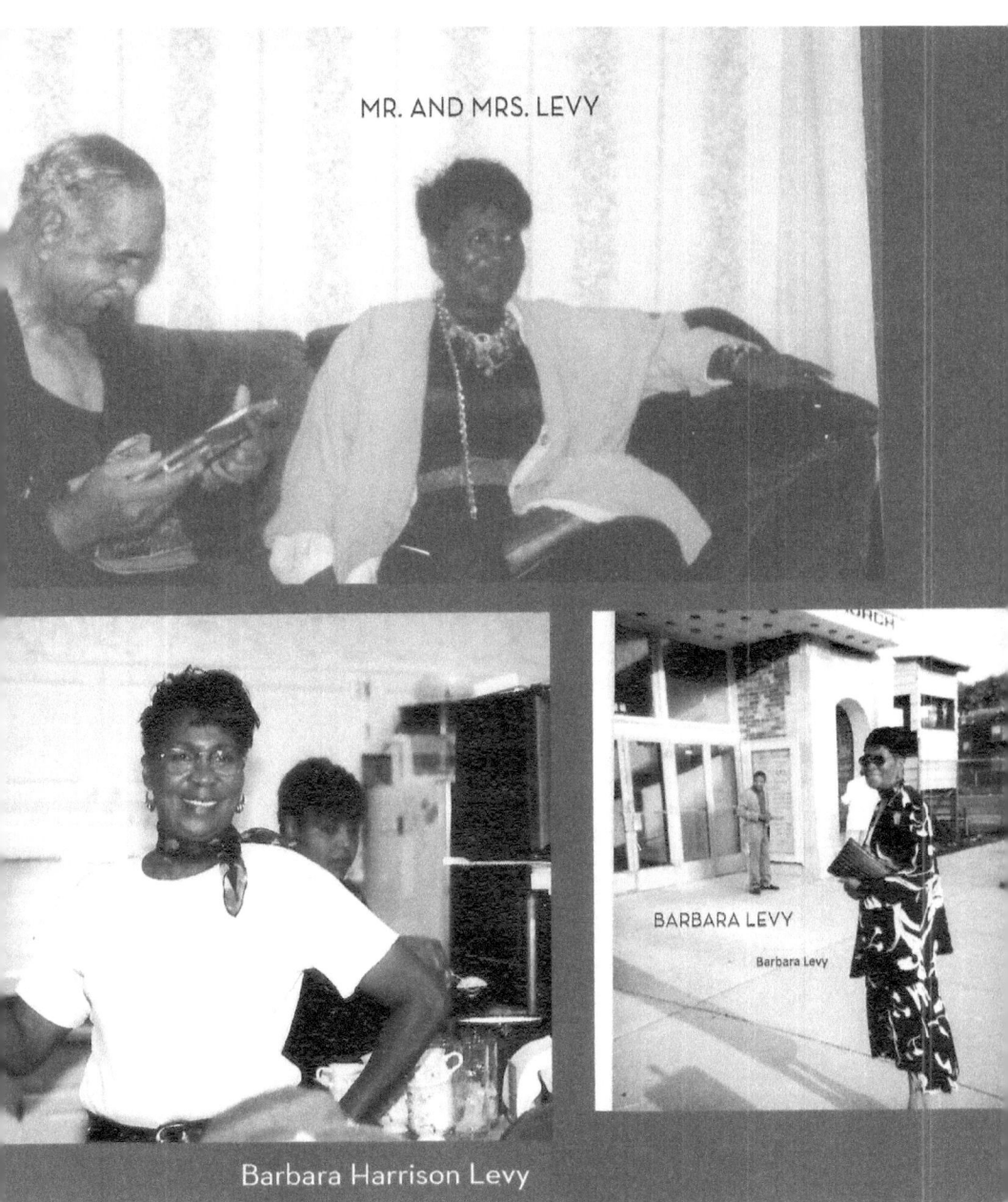

BARBARA TANYA
HARRISON
(with Mother) LEE
HARRISON

BENJAMIN HARRISON
(HUSBAND OF LEE
and FATHER OF
BARBARA TANYA)

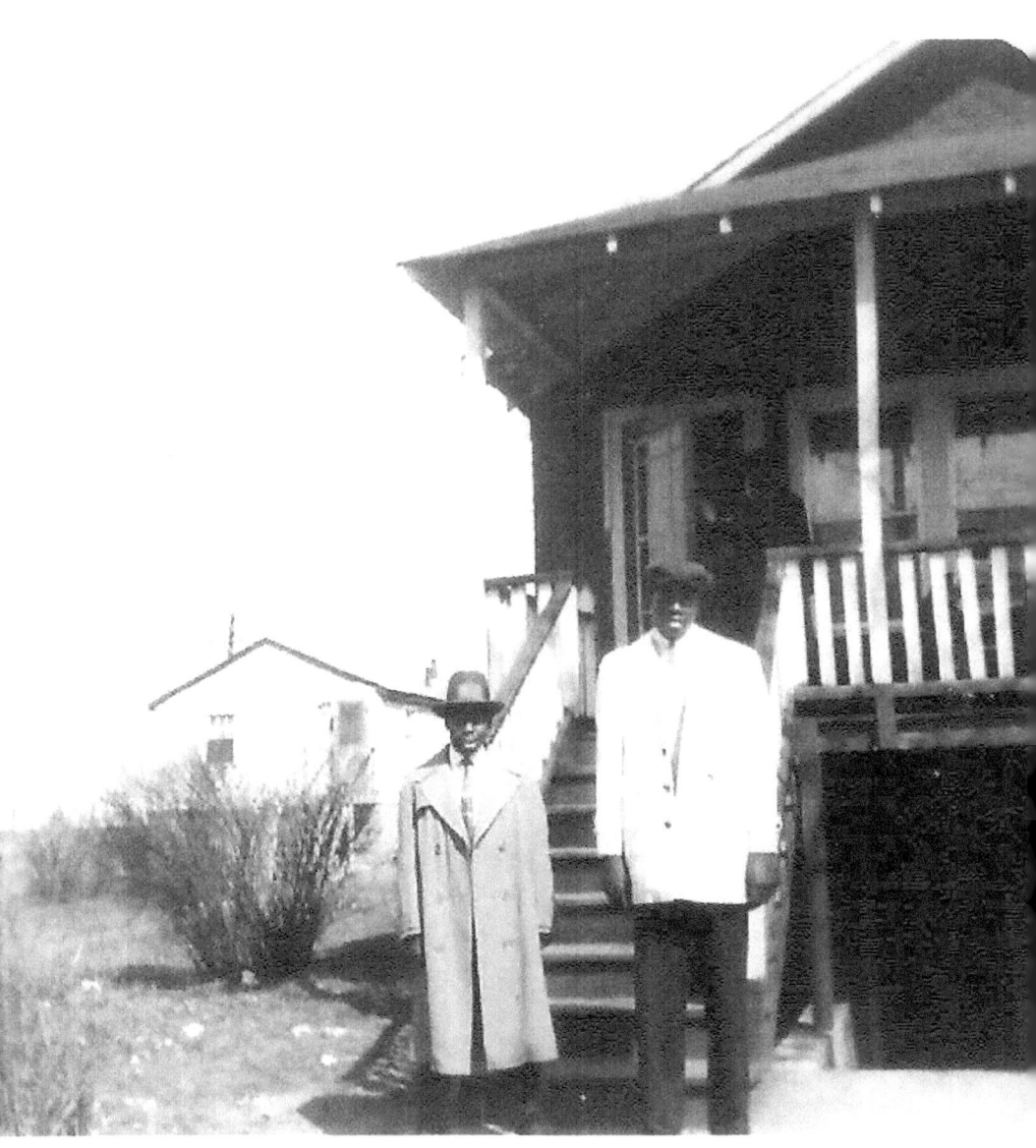

COUSINS
KENNETH HILL and BENJAMIN HARRISON (standing in front of 11317)

Charles and Crystal Warren Wilson
Children: Christian and Quentin

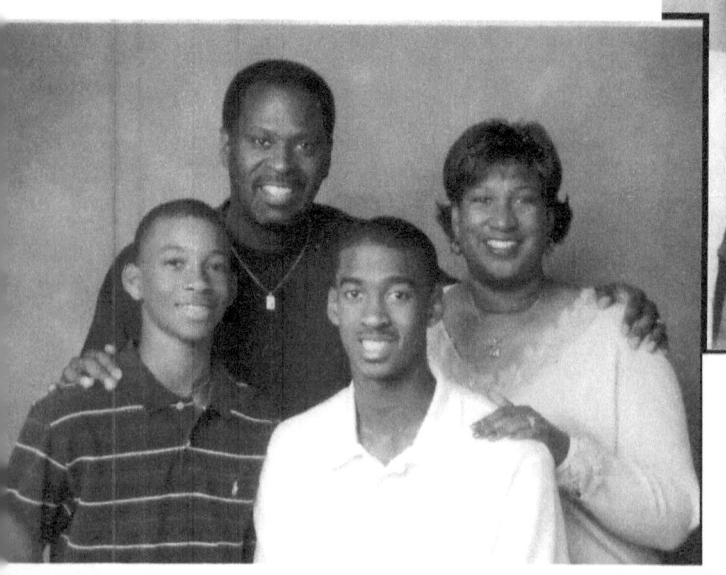

Keith and Sandra Warren Holder
Children: Kyle and Blake

KYLE and BLAKE HOLDER
CHRISTIAN and QUENTIN WILSON

COUSINS
GEORGE HIENSMAN and CHERIE WARREN

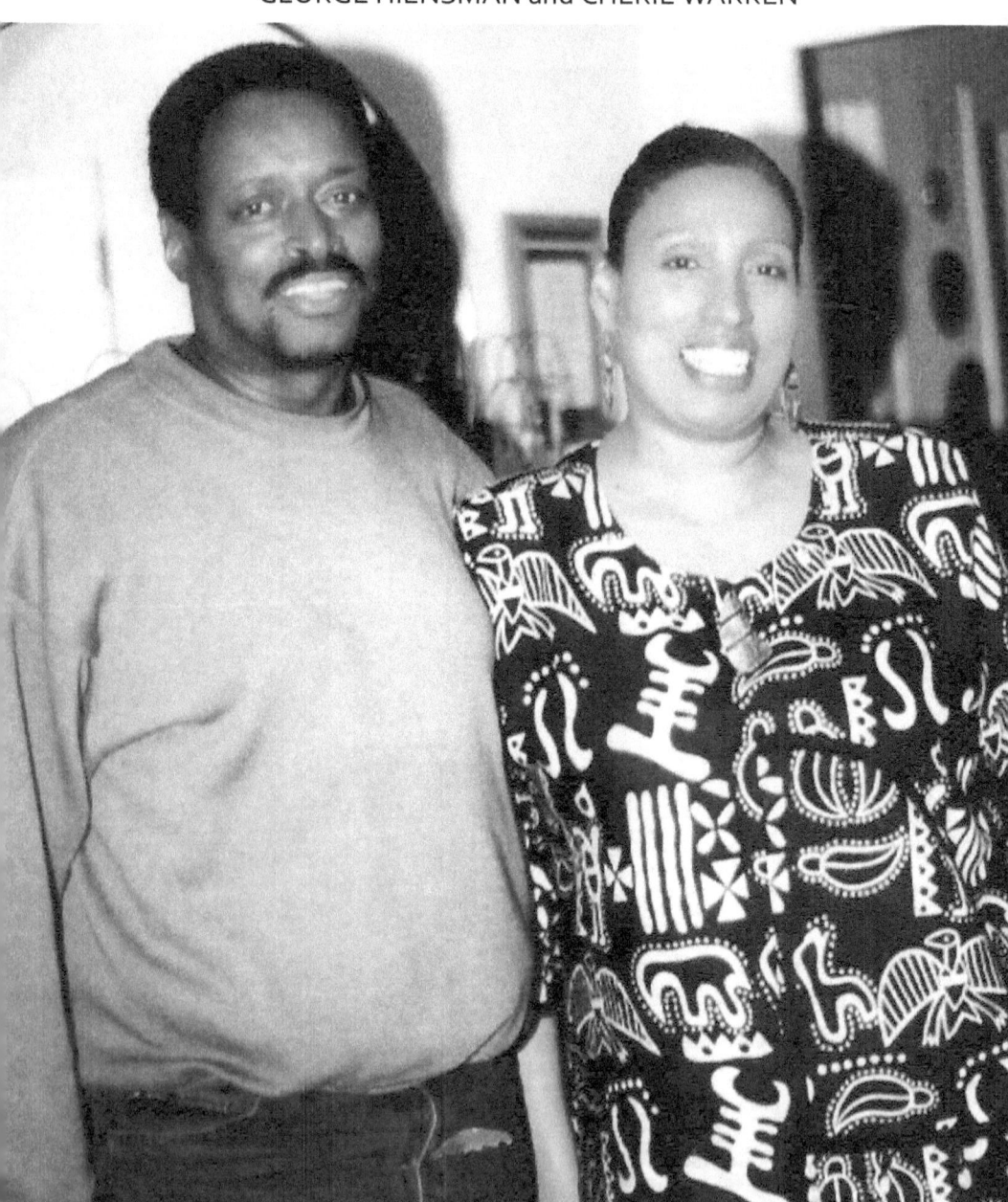

COUSINS
RONALD REDDITTE and BYRON HARRISON

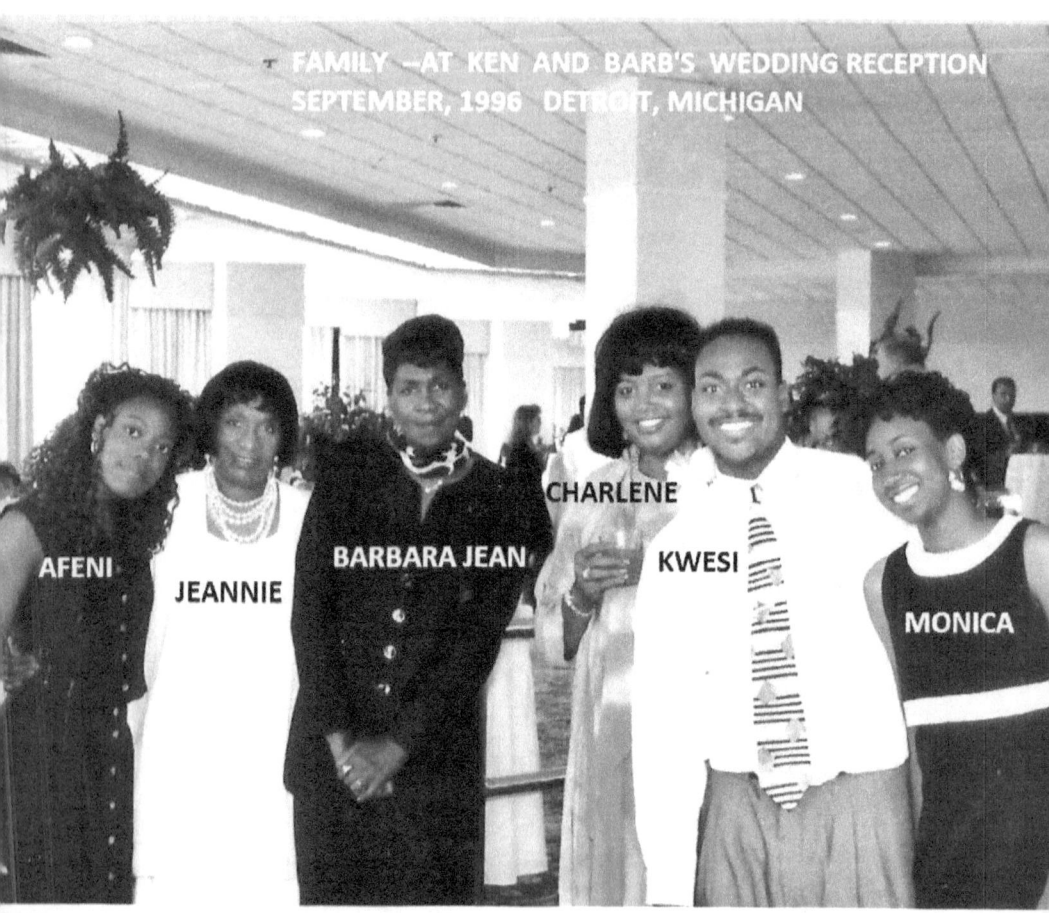

FAMILY — AT KEN AND BARB'S WEDDING RECEPTION SEPTEMBER, 1996 DETROIT, MICHIGAN

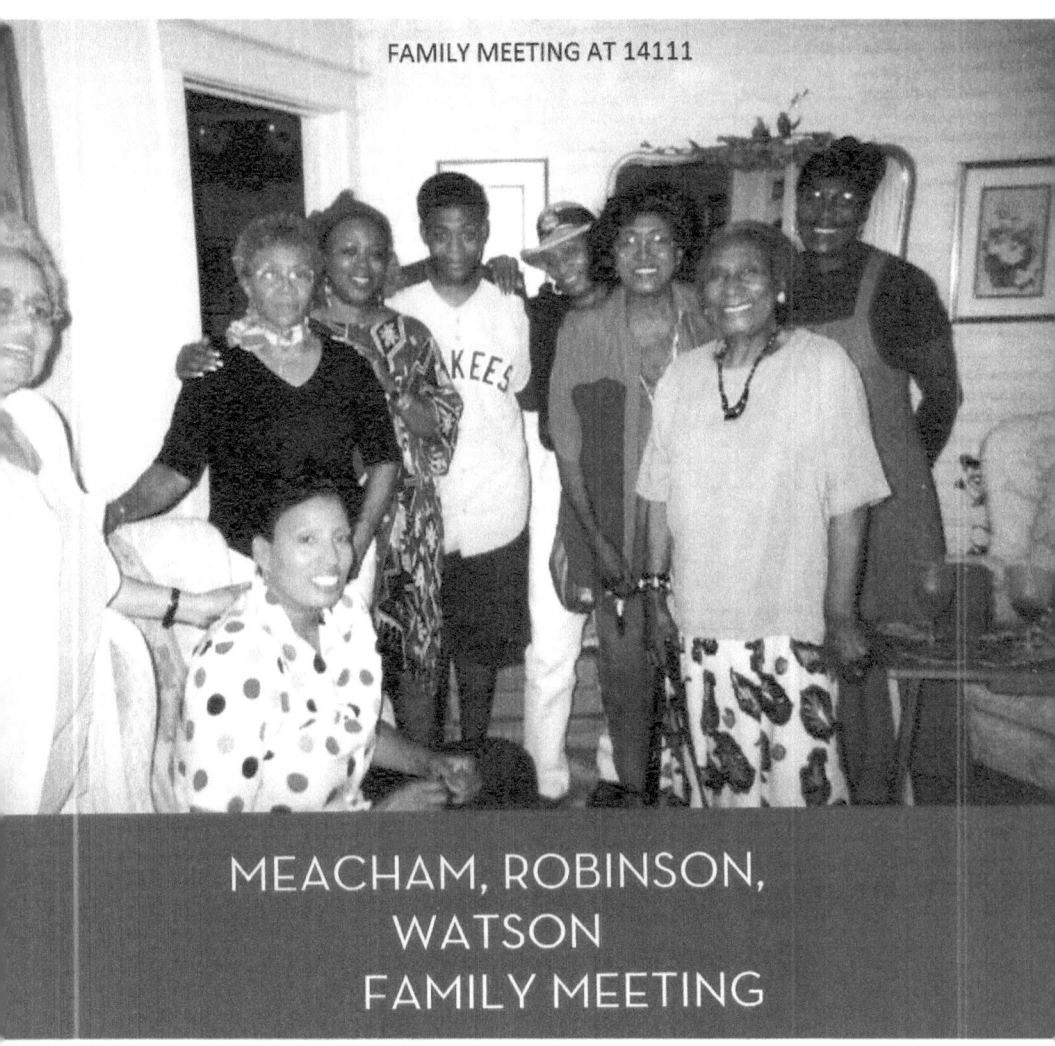

MEACHAM, ROBINSON, WATSON FAMILY MEETING

COUSINS

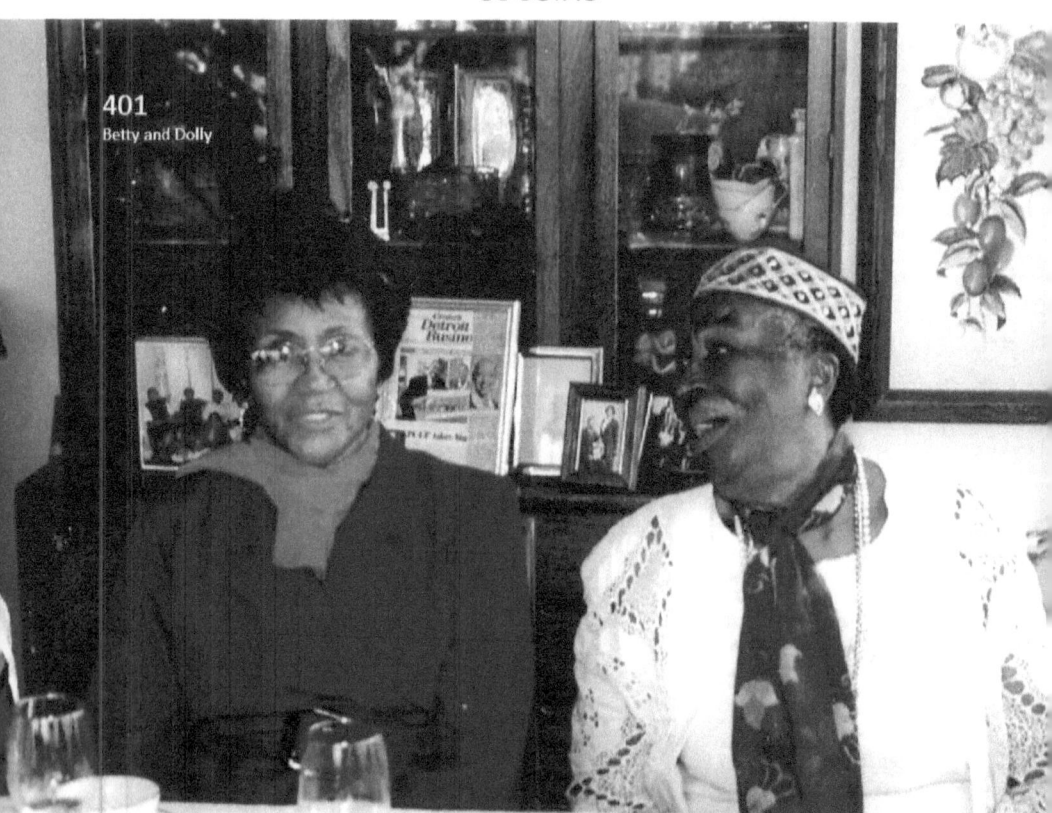

BETTY WATSON LOVE AND DOLLY ROBINSON HARRISON

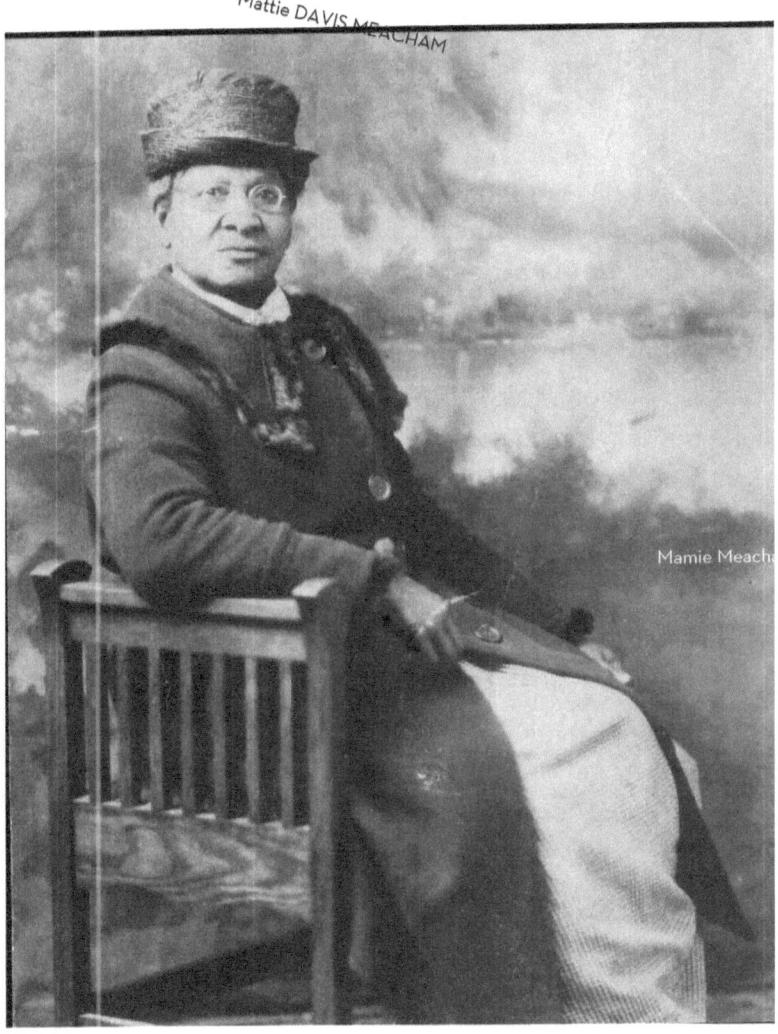

MATTIE DAVIS MEACHAM

(1860 MS - 1947 IL)

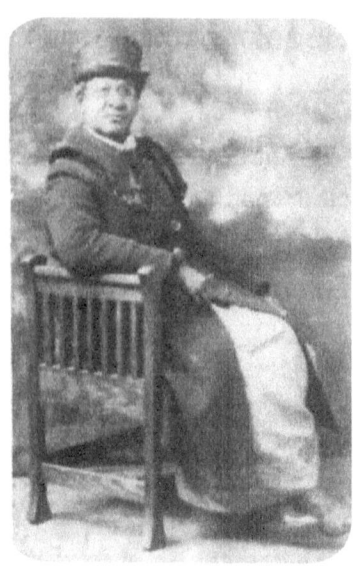

Mattie Davis Mecham
By, Marion Hill, Oct. 2009

Mattie Davis Meacham was born in 1860 to James Madison and Mary Davis in Marshall County, Mississippi. My research finds her in the 1870 census of DeSoto County, Miss. with individuals who would later be documented as: her mother, her stepfather Stephen Coppage, her sister Clara, her brothers, Wyatt and Thomas, and several stepbrothers and sisters. By the age of 16, she was married to a Mr. William Clayton and to this union one son William Clayton Jr. was born. No mention is made of Mr. Clayton again, but by 1880, records find Mattie married to Robert Meacham and living in Eastman Township, Pulaski County, Arkansas. Between 1881 and l89lchildren born to Mattie and Robert includes: Robert Jr., Lucy, Henry, Wayman, Mamie, and Irene. Mattie's son William Clayton Jr. is enumerated in the 1910 census as William Meacham (spelled Mitcham) with his wife Carrie, daughter Erma, and brother Henry living in Camden, Arkansas. Being an enterprising couple, Robert and Mattie purchased land in McAlmont, Arkansas. Robert worked as a blacksmith and farmer while Mattie ran a retail store and worked as Post Mistress. This employment is documented in the U.S.

Paris Joseph Van Pelt Sr

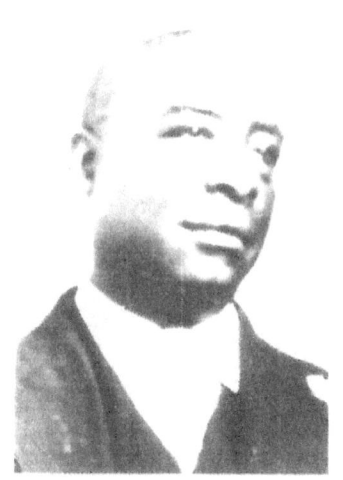

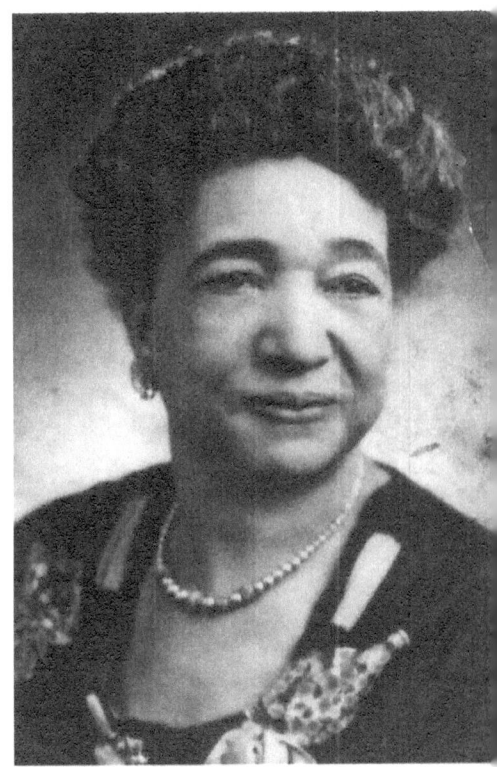

MAMIE MEACHAM VAN PELT

Mr. and Mrs. Van Pelt

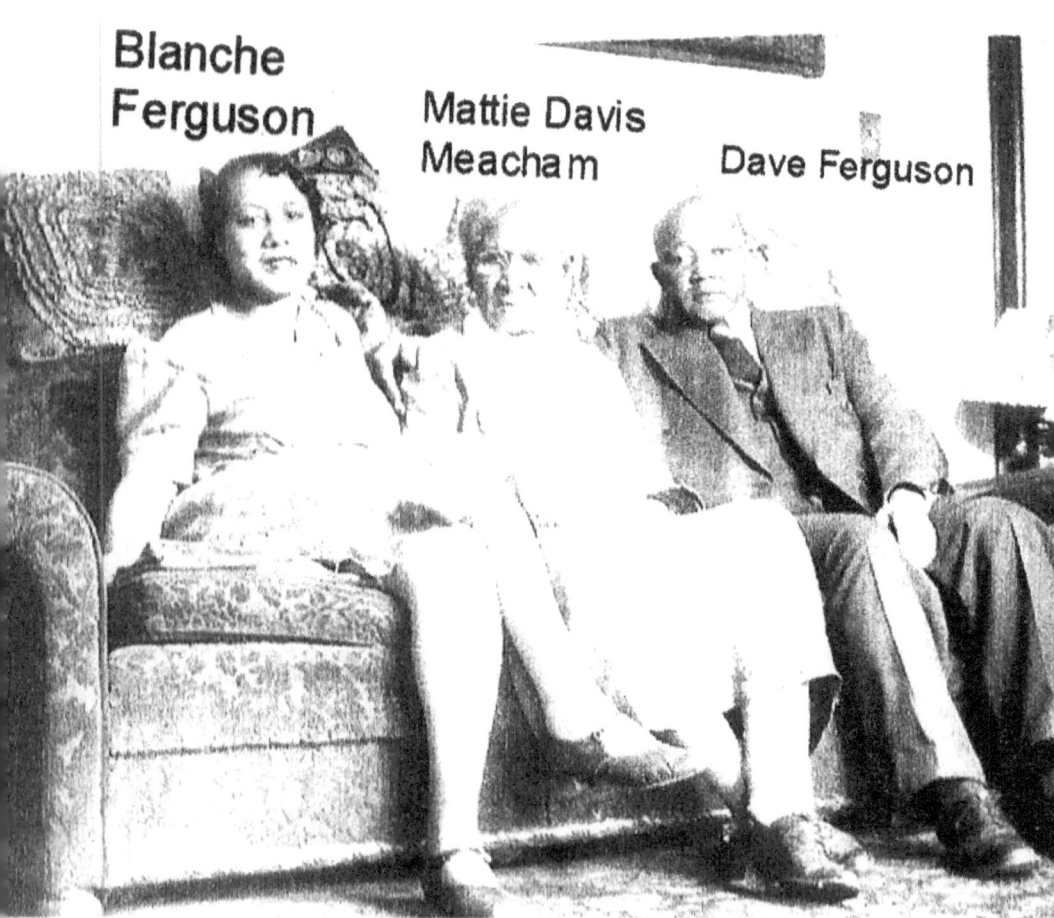

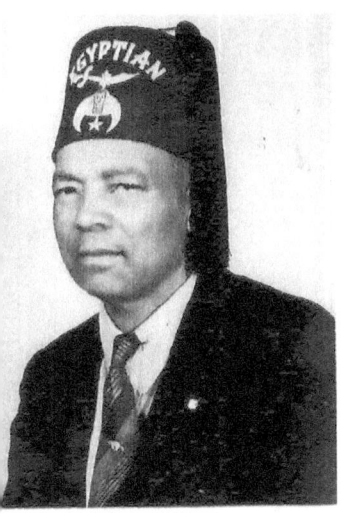

EDWARD MEACHAM

BROTHERS

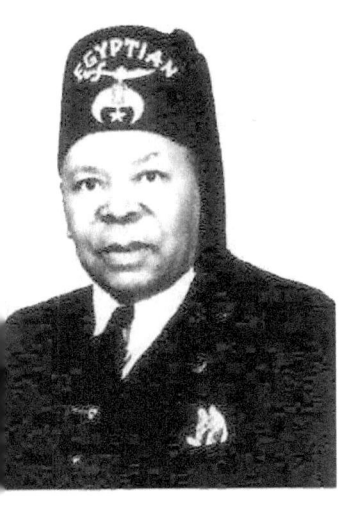

HENRY MEACHAM

MR. and MRS. ED MEACHAM

SISTERS Ruth Sands Jones
and
Patsy Sands Holland

Everett Andrew Sands, Jr

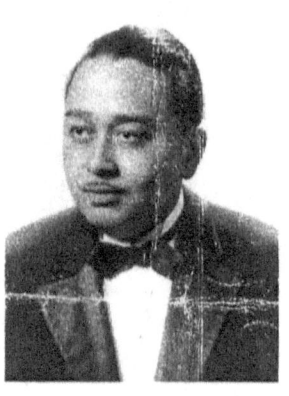

Everett Sands Jr. (Brother to Patsy
Sands Holland and Ruth Sands Jones)

COUSINS
Patsy Sands Holland
and
Jessie Robinson Mclaughlin

FROM LEFT

1. Dolly Robinson Harrison
2. Sandra Holland Bell
3. Patsy Sands Holland
4. Charlene T. Mclaughlin
5. Jessie Robinson Mclaughlin
6. Cherie Warren

COUSINS

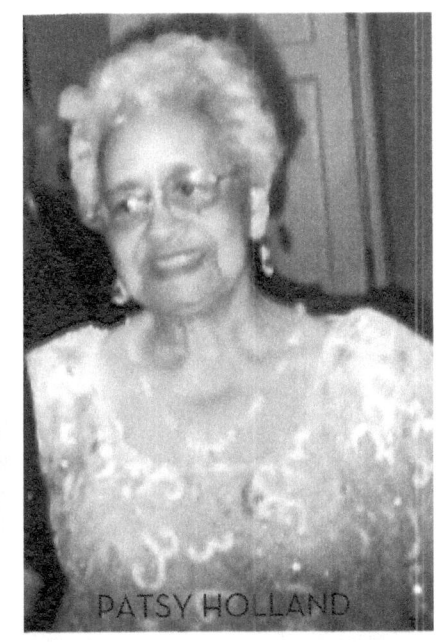

Murray Holland

Above: Mr. and Mrs. Holland

Right: Patsy Holland and Mother Mattie Meacham Sands

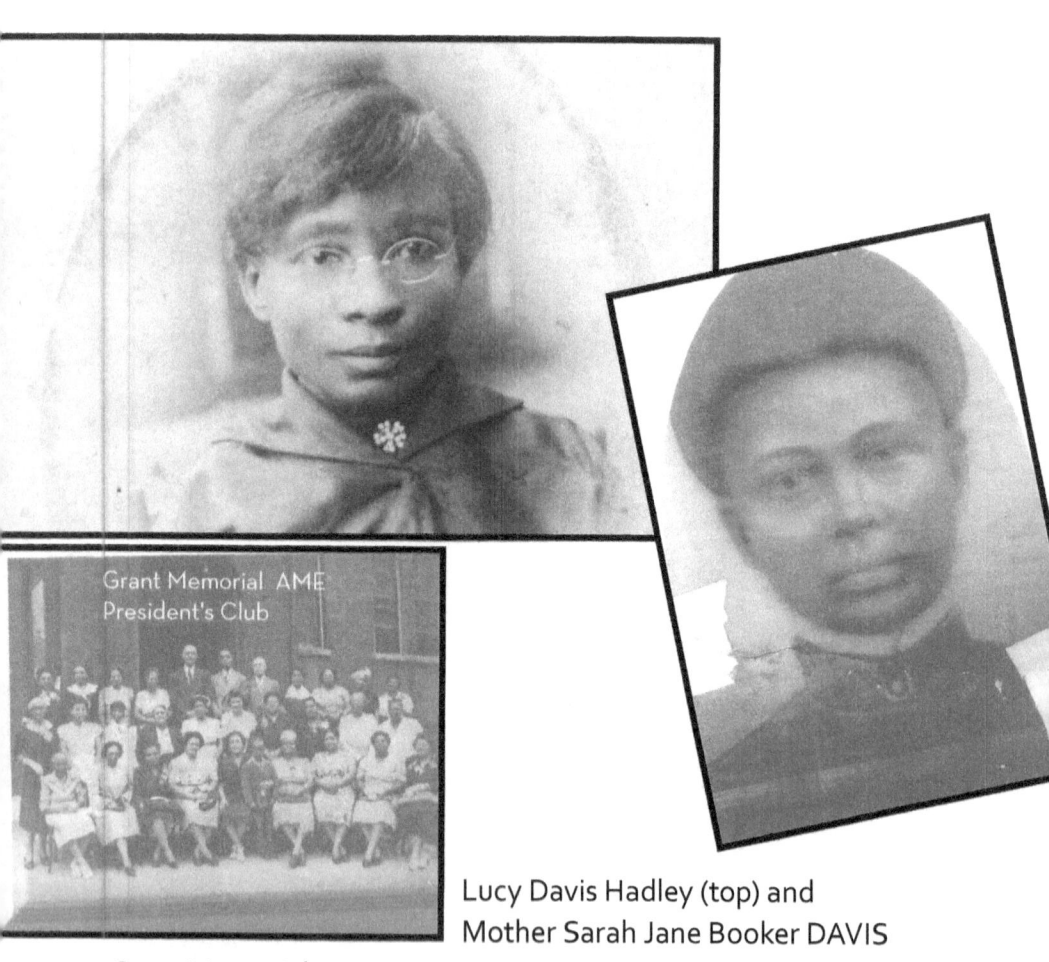

Lucy Davis Hadley (top) and
Mother Sarah Jane Booker DAVIS

Grant Memorial AME
Presidents Club

AUBREY ROBINSON

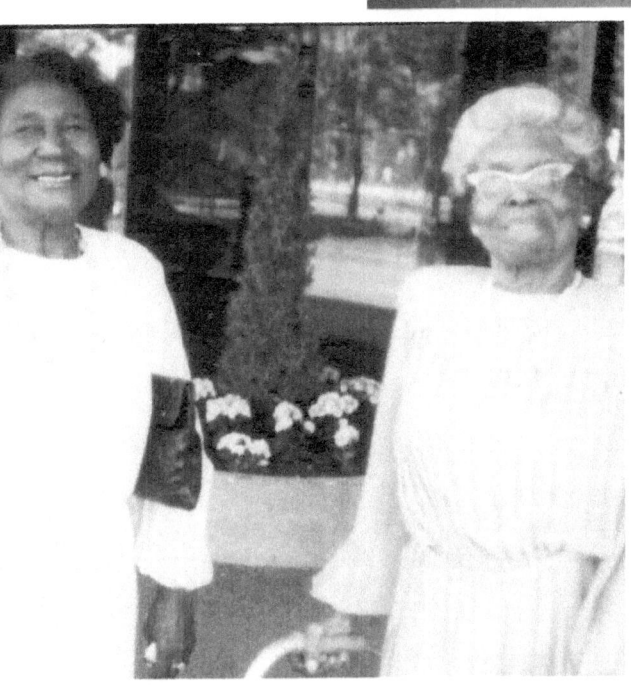

HELEN HILL (niece)
LENA DAVIS (aunt)

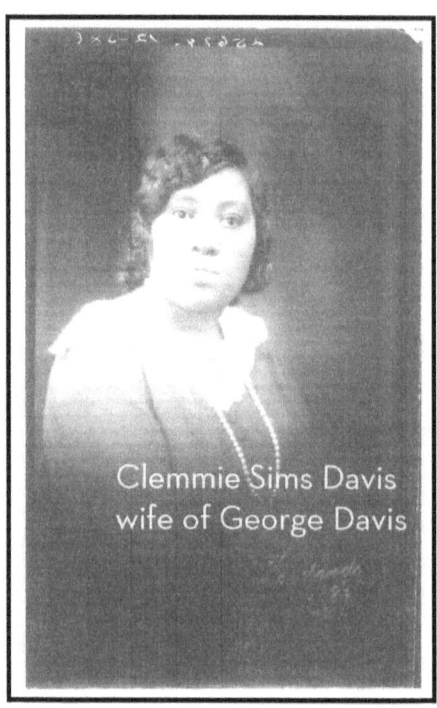

COUSINS

CLEMMIE DAVIS
Husband (George Davis)

LENA SIMS DAVIS
Husband (Sandy Davis)

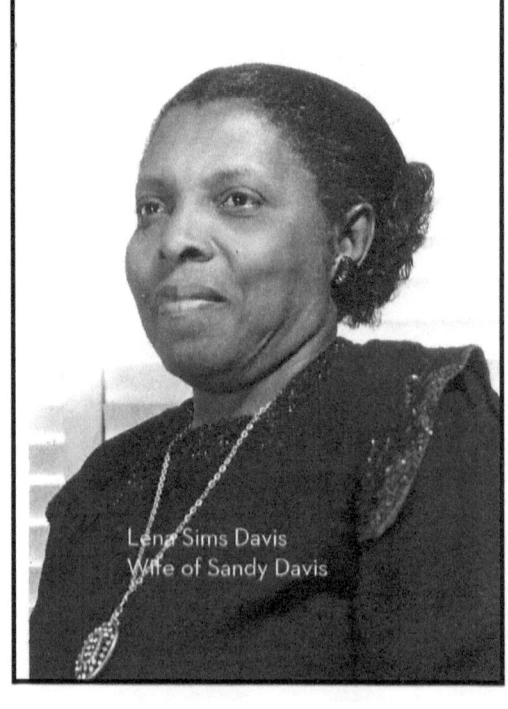

NIECE and AUNT

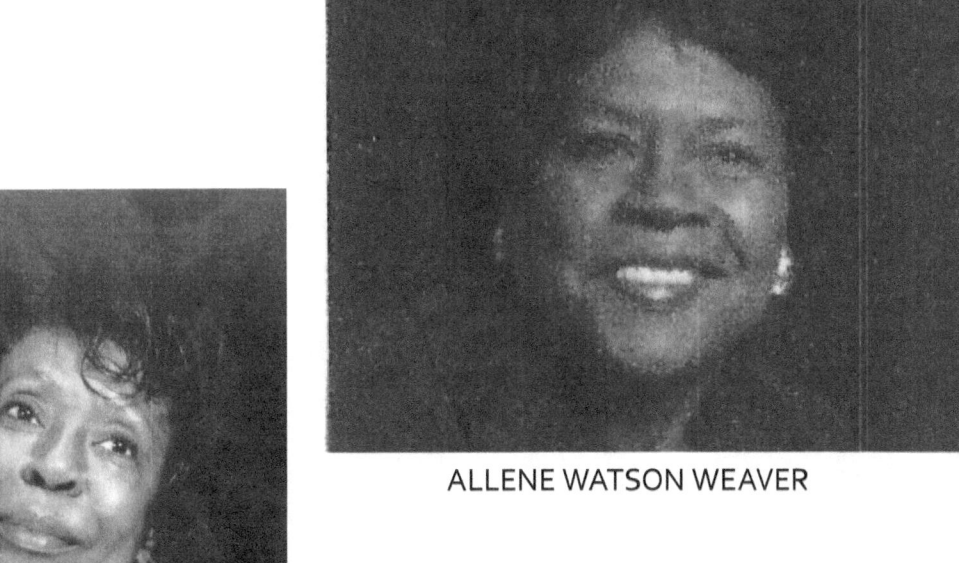

ALLENE WATSON WEAVER

MARGARETTE WATSON OLIVER

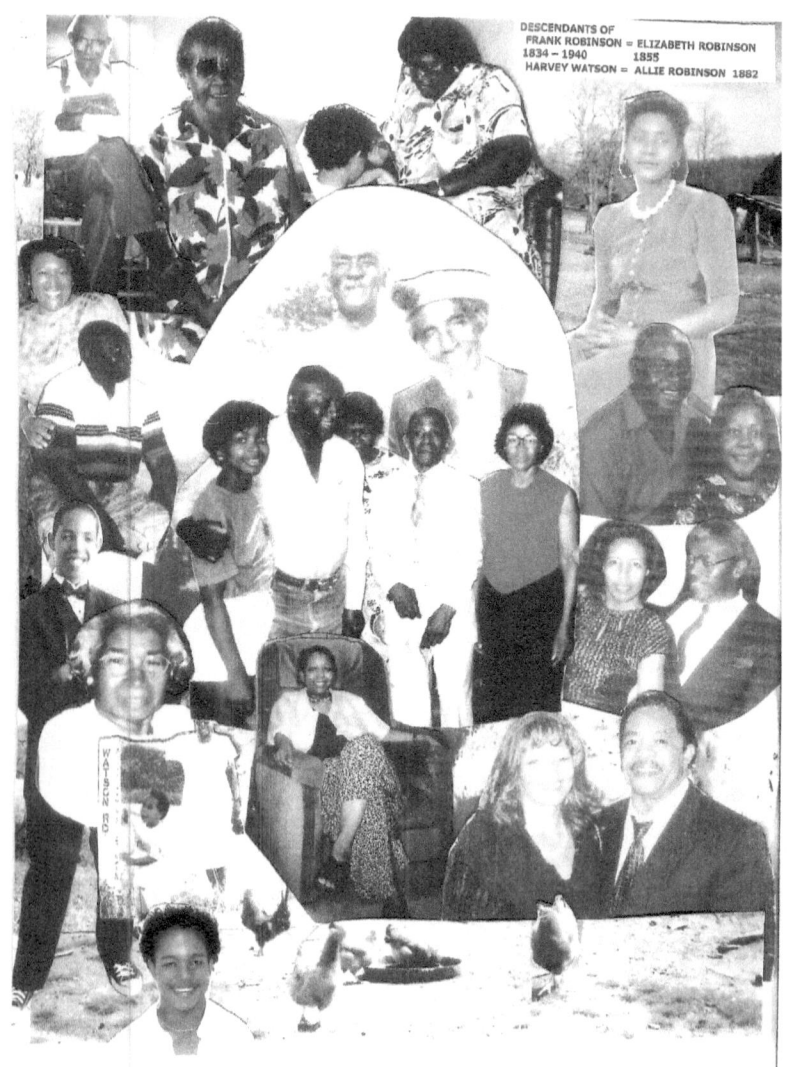

WATSON FAMILY

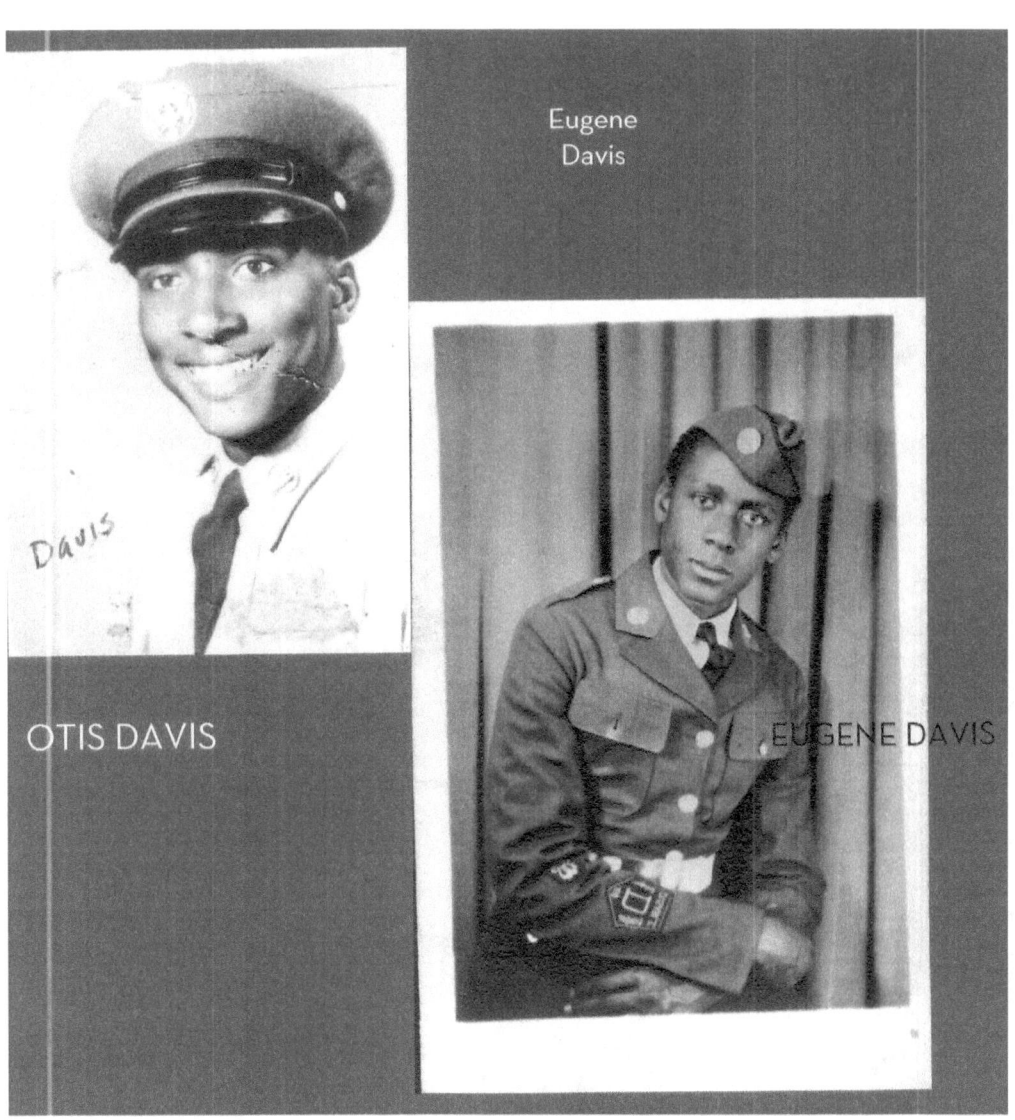

Eugene Davis

OTIS DAVIS

EUGENE DAVIS

Vivian I. May

Parents (below)

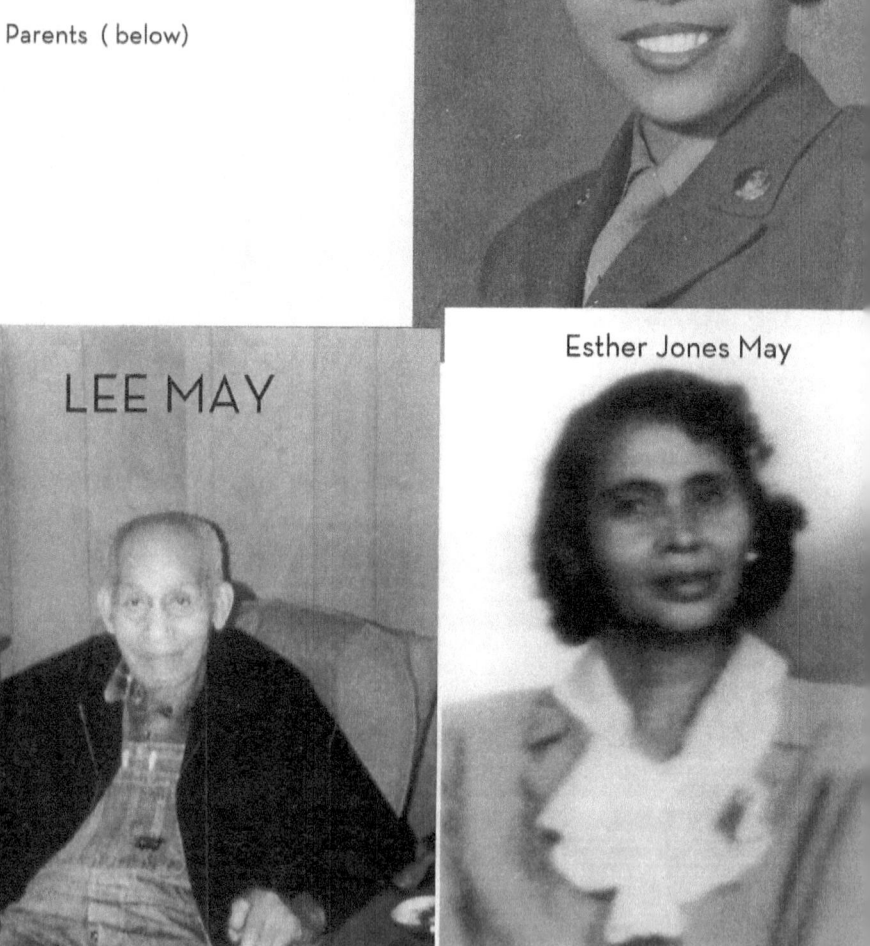

LEE MAY

Esther Jones May

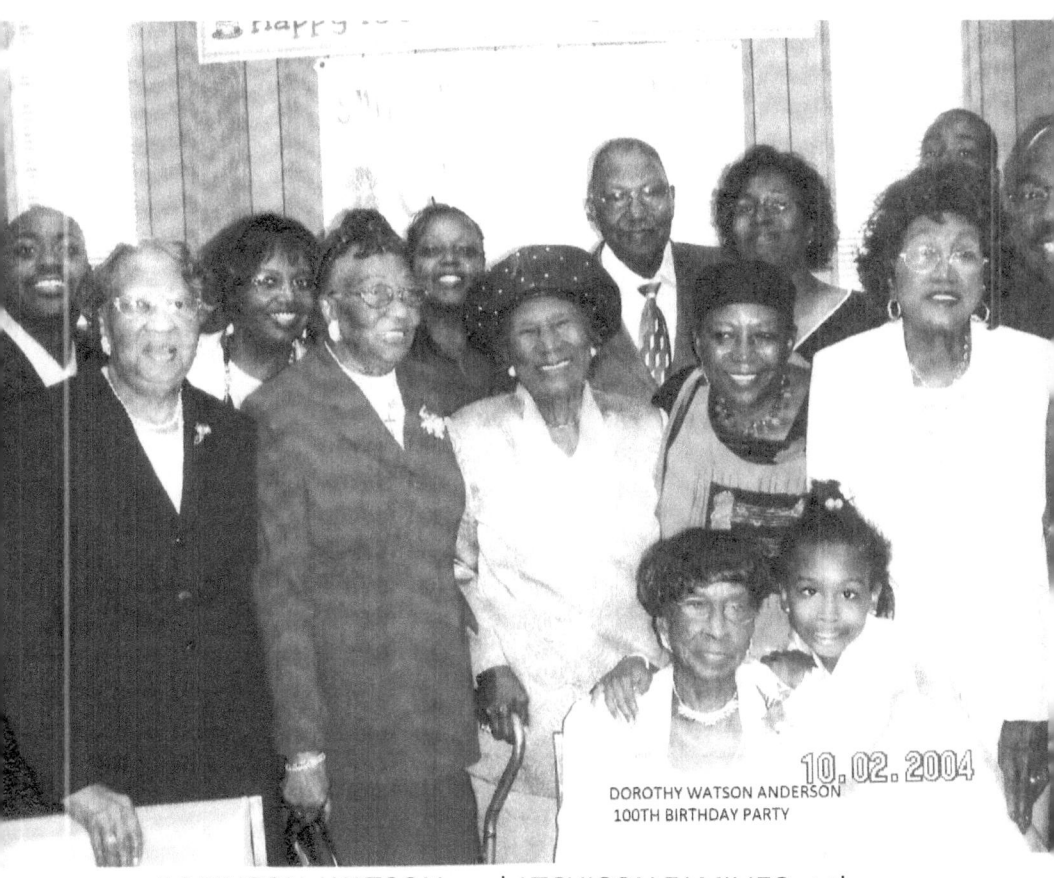

ROBINSON, WATSON, and ATCHISON FAMILIES at the 100th BIRTHDAY PARTY OF DOROTHY Atchison WATSON –ANDERSON

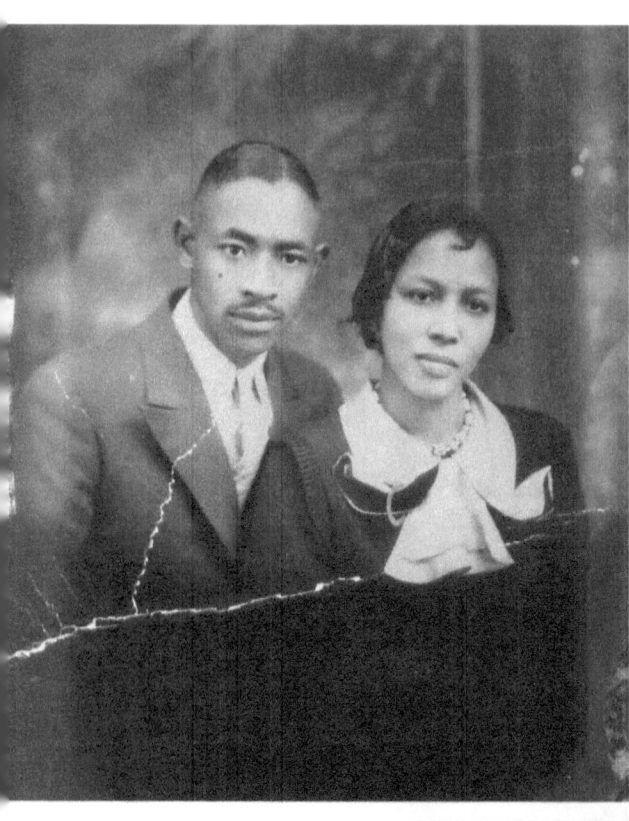

BROTHERS

ZEBBIE and DOROTHY
Atchison WATSON

TOM and DORIS
Martin WATSON

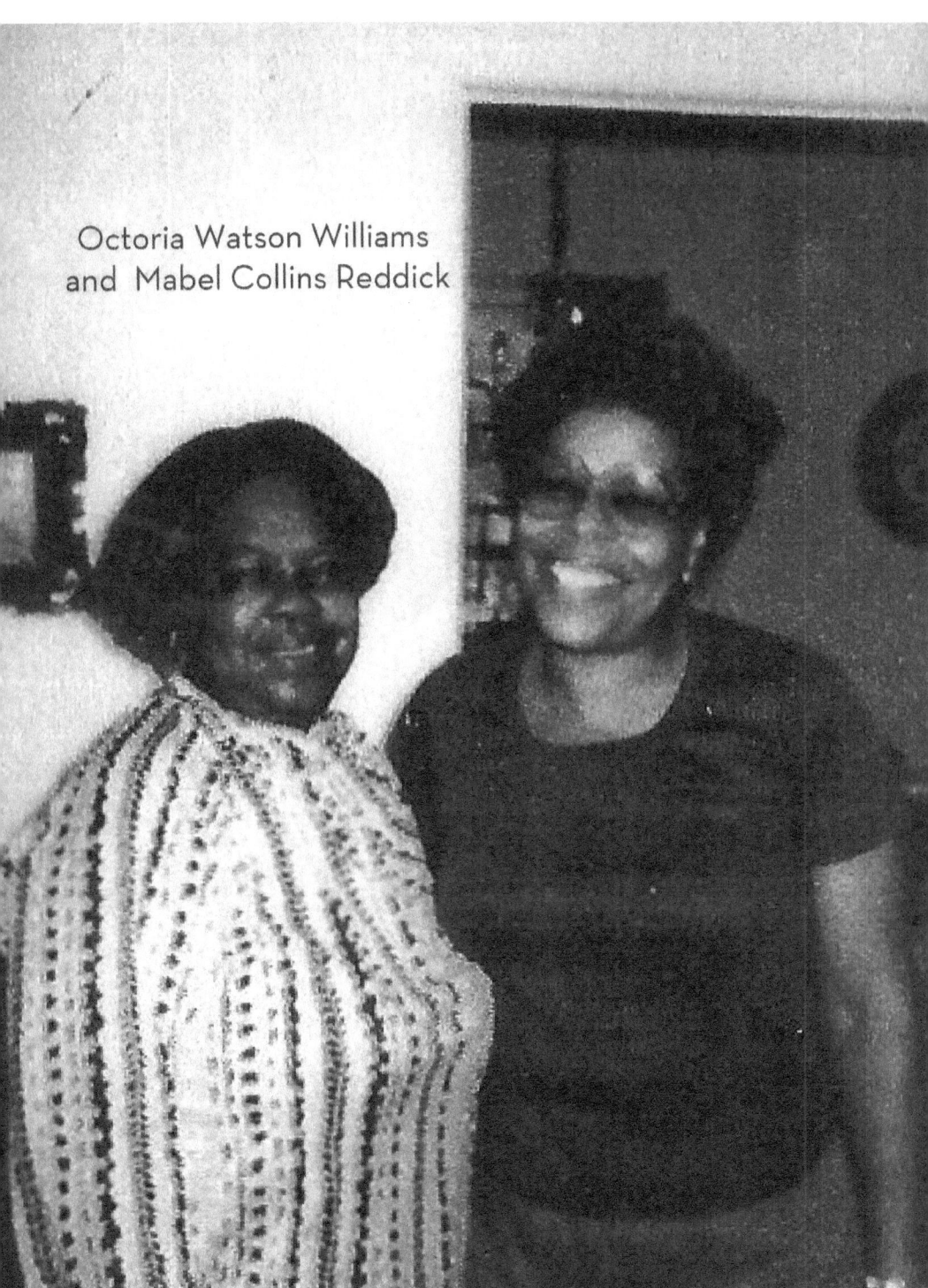
Octoria Watson Williams and Mabel Collins Reddick

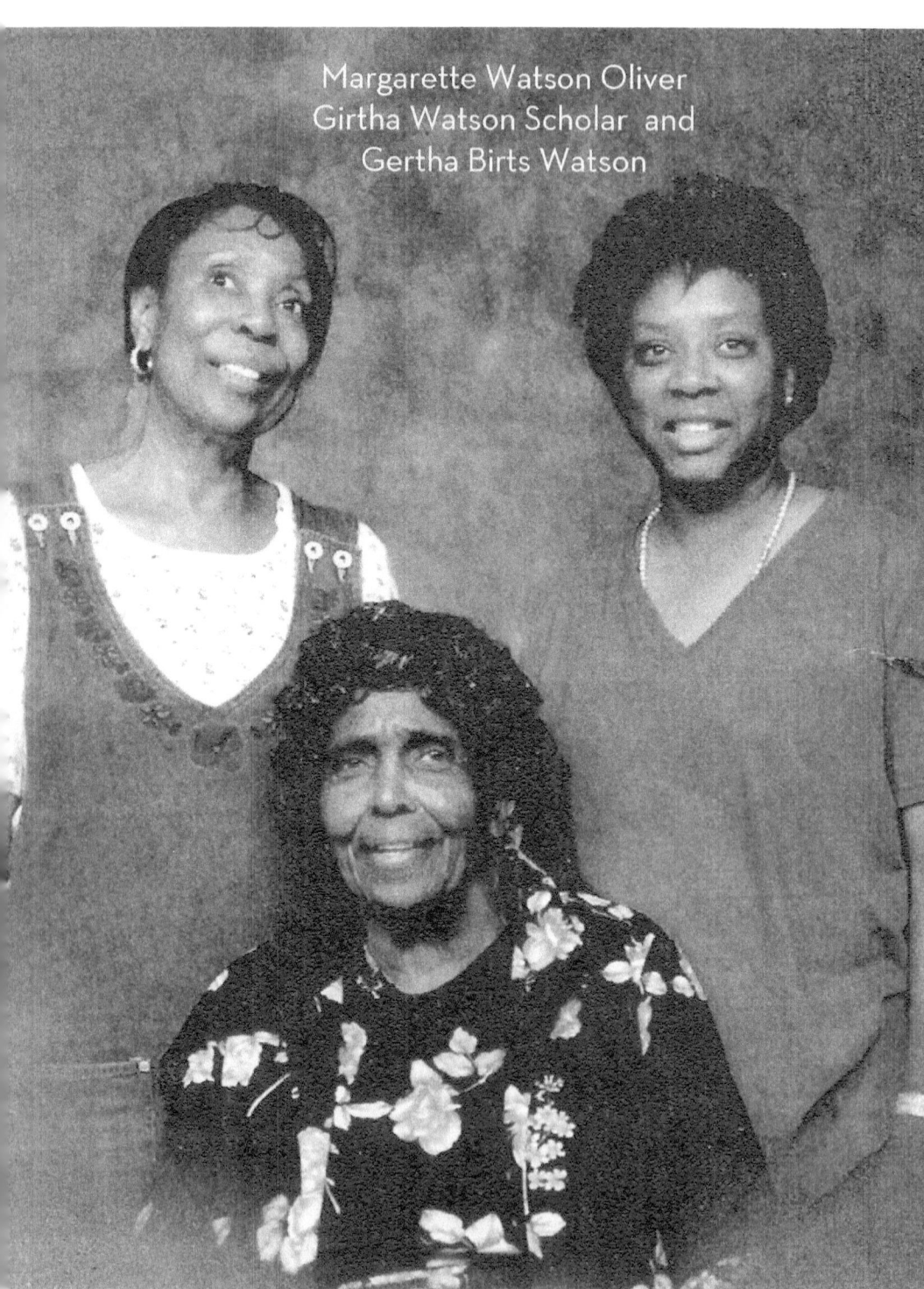
Margarette Watson Oliver
Girtha Watson Scholar and
Gertha Birts Watson

Dawn, Jonathan, and Harvey WATSON and Puppy Peanut

Elizabeth Watson Oscar
Mother of Rochelle EllisonYoung
Sister of Edna Ruth Watson
Grandmother of Lynn Cheeks

Rochelle EllisonYoung, Lynn Cheeks, and Edna Ruth Watson

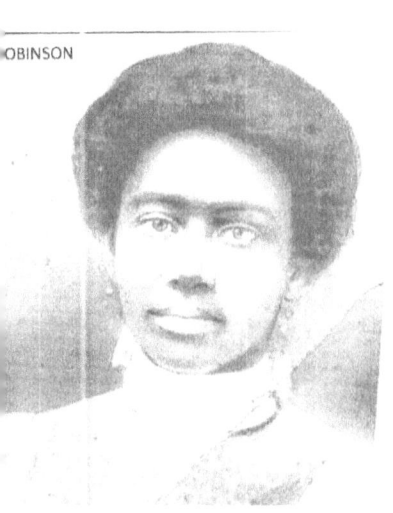

MARY Davis Robinson

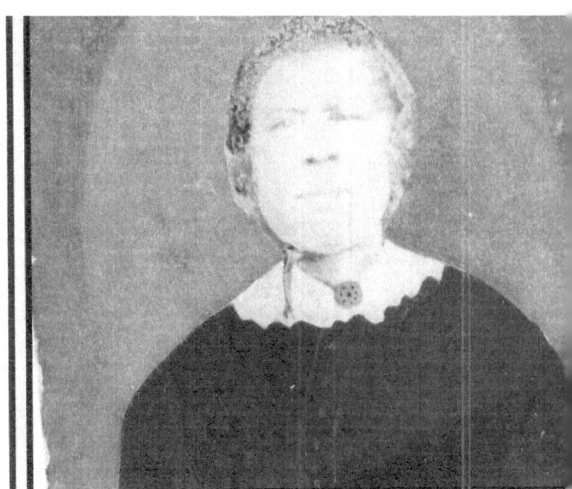

MARY Davis Coppage

MARY Davis Taylor

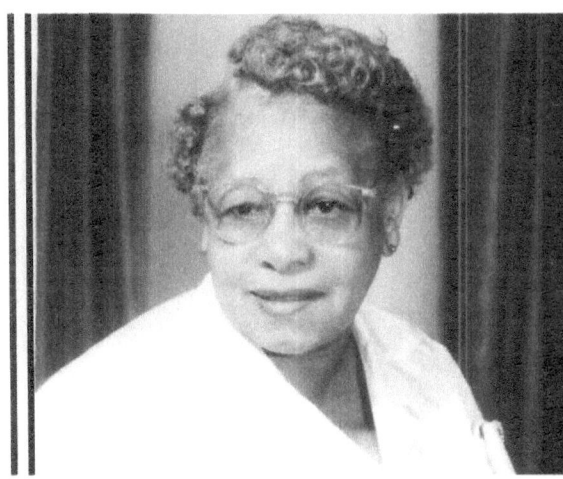

MARY Webster Watson

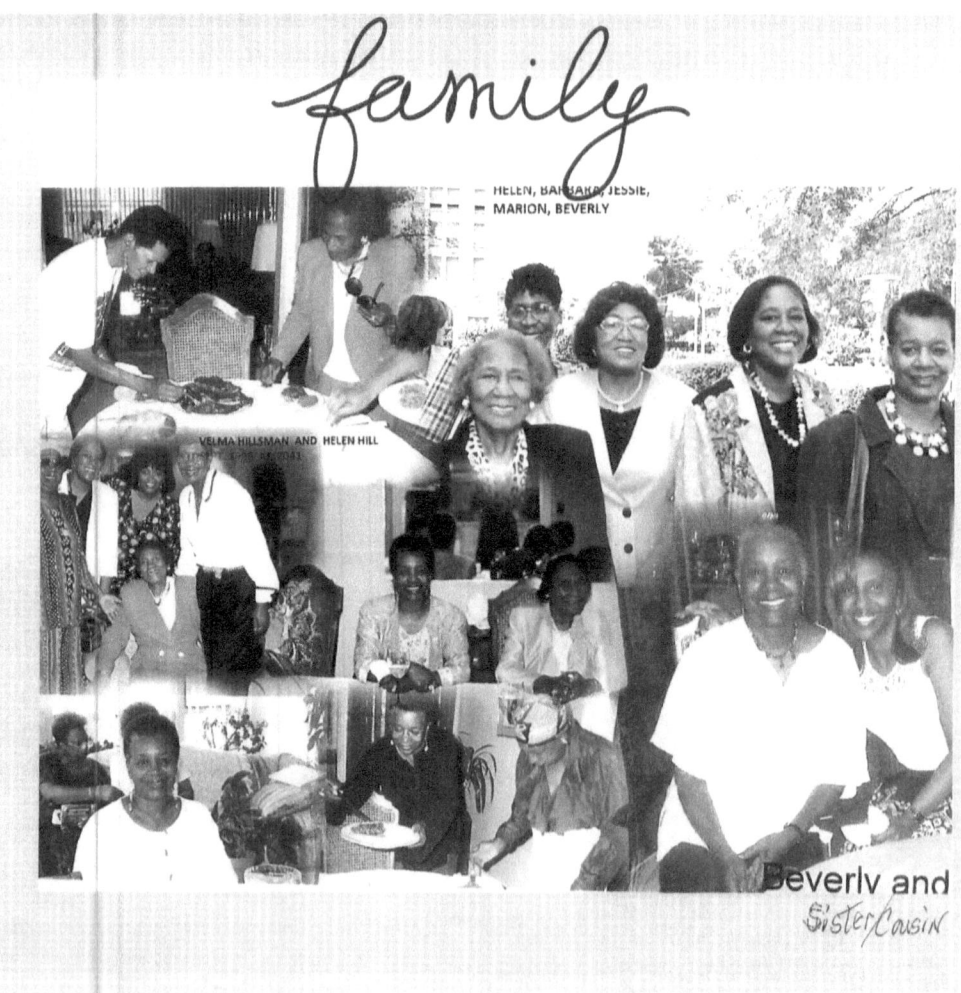

Helen Robinson Hill's
100th Birthday Party

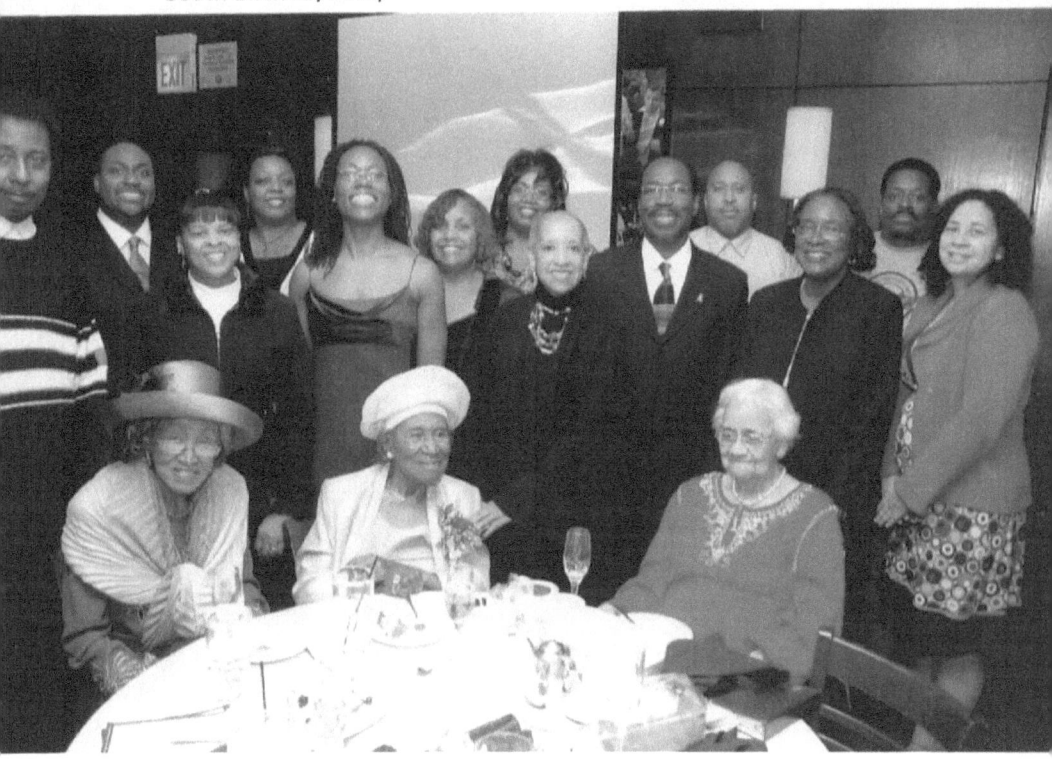

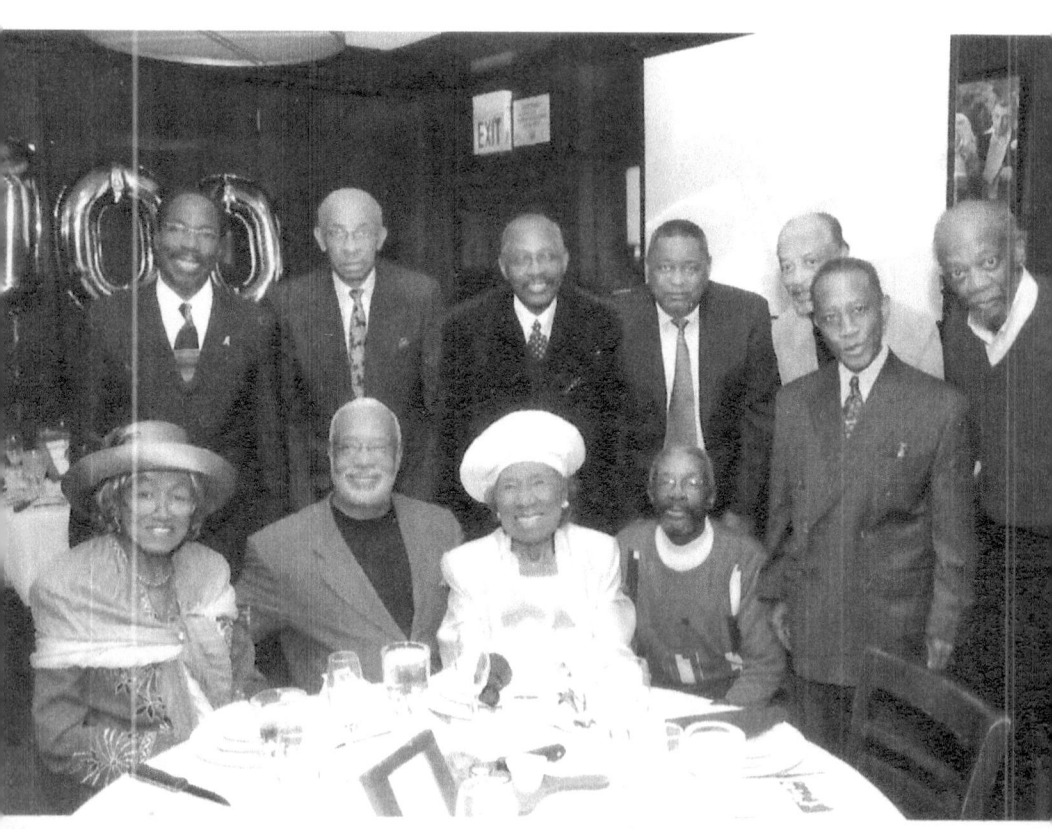

HELEN ROBINSON HILL's 100th BIRTHDAY PARTY
FRIENDS and FAMILY PORTRAIT

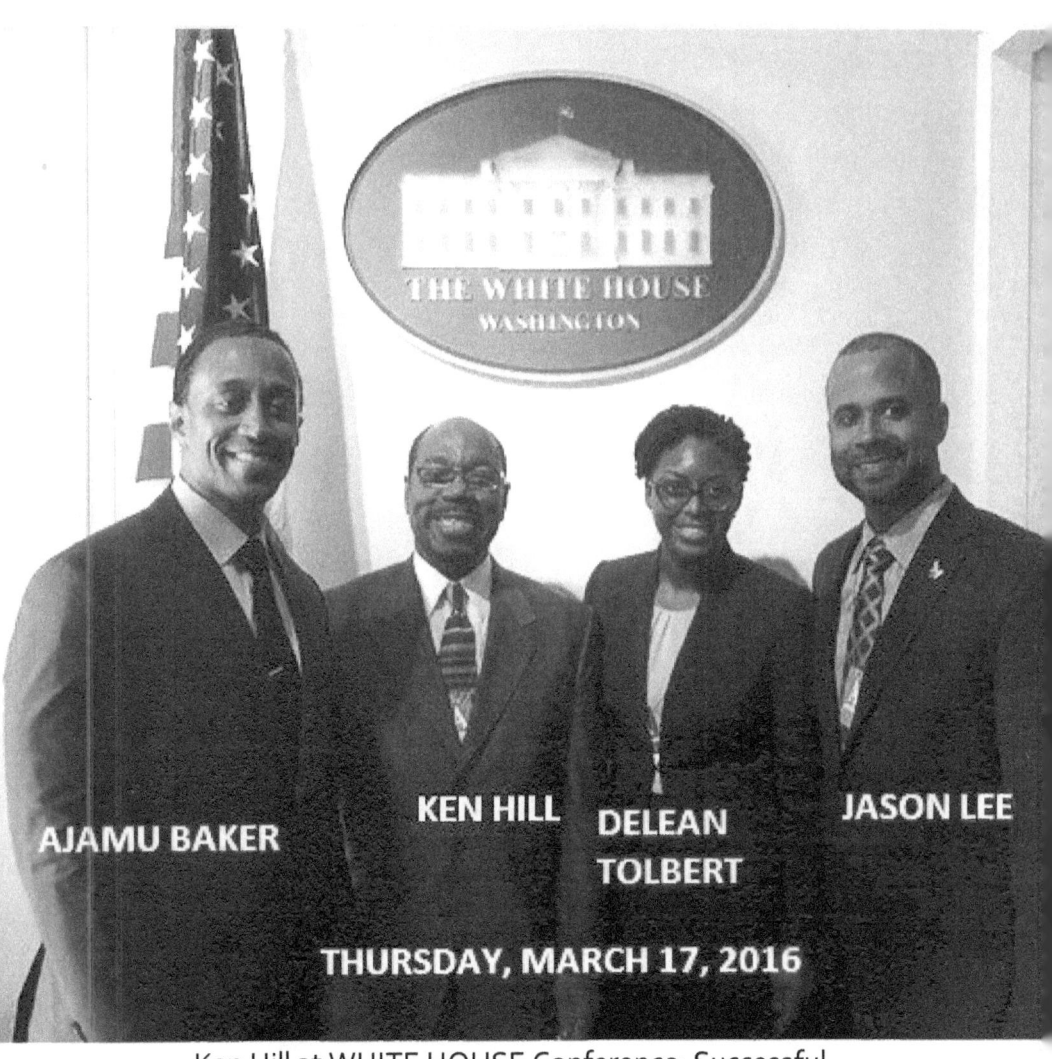

Ken Hill at WHITE HOUSE Conference: Successful Strategies from Schools and Youth Agencies That Build Ladders of Opportunity

www.ingramcontent.com/pod-product-compliance
Lightning Source LLC
Chambersburg PA
CBHW021448210526
45463CB00002B/684